*anim*

D0337841

National
Gallery

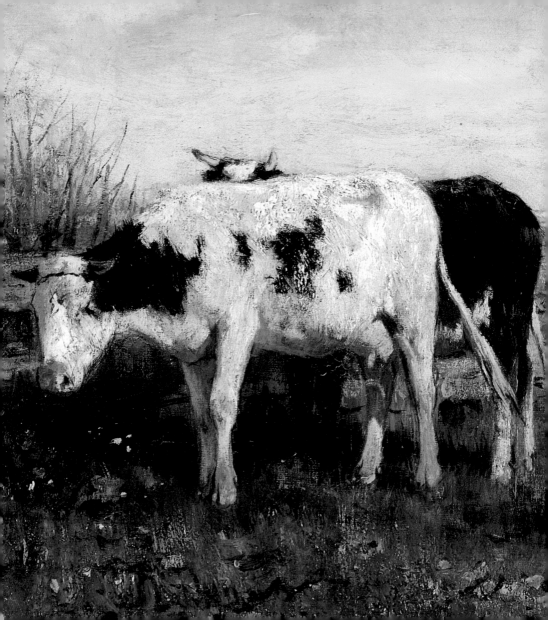

*animals in* art

National
Gallery

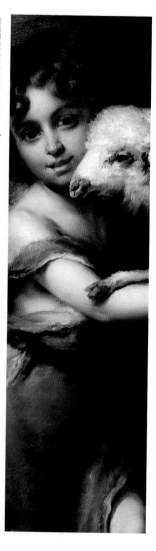

Bartolomé Esteban Murillo: detail of *The Infant Saint John with the Lamb*

First published in the United States in 2000 by
Watson-Guptill Publications
a division of BPI Communications, Inc.
1515 Broadway
New York, NY 10036

Series editor: Ljiljana Ortolja-Baird
Designer: Julie Francis
Design concept: Bet Ayer

Library of Congress Card Number: 99–68596

ISBN: 0–8230–0339–6

First published in the United Kingdom in 2000 by
MQ Publications Ltd., 254–258 Goswell Road,
London EC1V 7RL in association with
National Gallery Company Ltd., London.

Printed and bound in Italy

1 2 3 4 5 6 7 8 /07 06 05 04 03 02 01 00

Title page: Anton Mauve, *Milking Time*

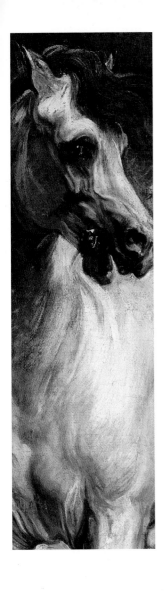

# INTRODUCTION

"As painting, so poetry." Like all siblings, the Sister Arts are rivals and allies. In the mirrors they hold up to nature we see ourselves and the world around us reflected from varying angles and by different lights.

The National Gallery in London houses many of the world's most famous paintings, many of which celebrate the wonder and diversity of the animal kingdom. The full range of mankind's constantly changing attitudes to and interaction with animals is shown in these apt juxtapositions of image and text: animals are variously portrayed as fearsomely wild beasts; beloved, precious pets; domestic helpmates; and, sometimes, as religious symbols and allegories.

By exploring each painting in detail, *Animals in Art* helps us discover aspects of these images we never "knew" were there, and by pairing text and picture, it enhances the powerful descriptive powers of both painting and literature, encouraging us to hone our responses to each.

Erika Langmuir
Head of Education, National Gallery, 1988–1995

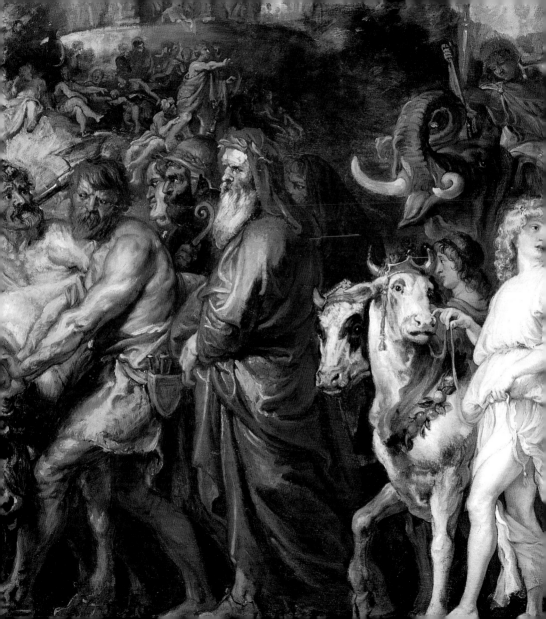

exotic

JEAN-AUGUSTE-DOMINIQUE INGRES (1780–1867)
French
*Angelica saved by Ruggiero*
1819–39

*How to make an imaginary animal appear natural*
You know that you cannot make any animal without it
having its limbs such that each bears some resemblance to
that of some one of the other animals. If therefore you wish
to make one of your imaginary animals appear natural—
let us suppose it to be a dragon—take for its head that of a
mastiff or setter, for its eyes those of a cat, for its ears those
of a porcupine, for its nose that of a greyhound, with the
eyebrows of a lion, the temples of an old cock and the
neck of a water-tortoise.

<div align="right">

from *The Notebooks of Leonardo da Vinci,*
early 16th century

</div>

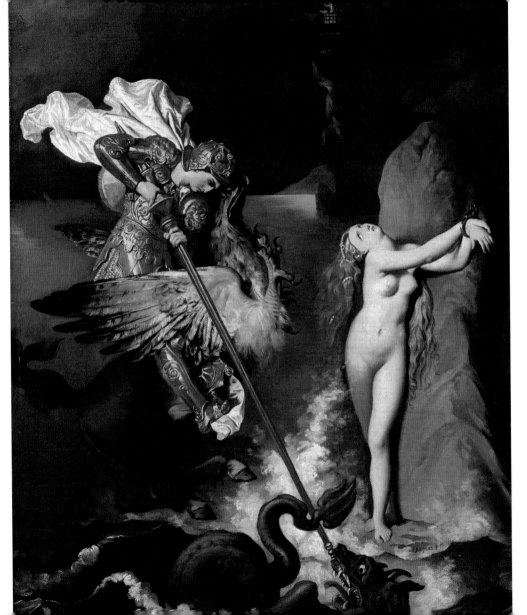

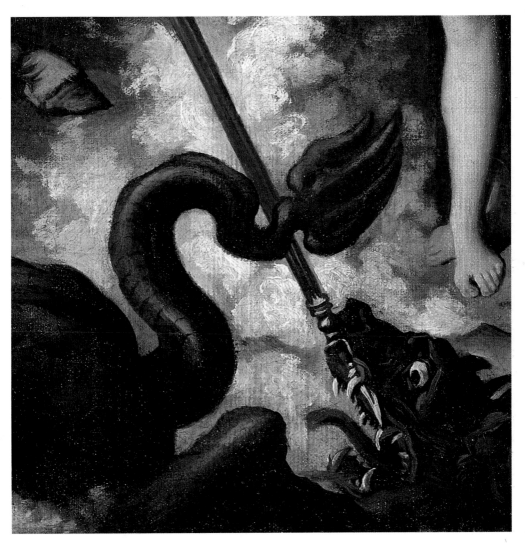

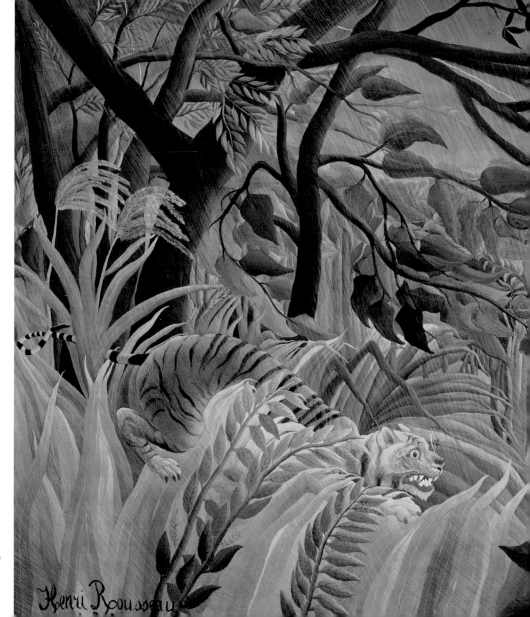

14

Henri Rousseau

HENRI ROUSSEAU (1844–1910) French
*Tiger in a Tropical Storm (Surprised!)*
1891

They hunt, the velvet tigers in the jungle,
The spotted jungle full of shapeless patches—
Sometimes they're leaves, sometimes they're hanging
    flowers,
Sometimes, they're hot gold patches of the sun:
They hunt, the velvet tigers in the jungle!

What do they hunt by glimmering pools of water,
By the round silver Moon, the Pool of Heaven?—
In the striped grass, amid the barkless trees—
The stars scattered like eyes of beasts above them!

What do they hunt, their hot breath scorching
    insects?
Insects that blunder blindly in the way,
Vividly fluttering—they are also hunting,
Are glittering with a tiny ecstasy!

The grass is flaming and the trees are growing,
The very mud is gurgling in the pools,
Green toads are watching, crimson parrots flying,
Two pairs of eyes meet one another glowing—
They hunt, the velvet tigers in the jungle.

*India,*
W.J. TURNER, 1916

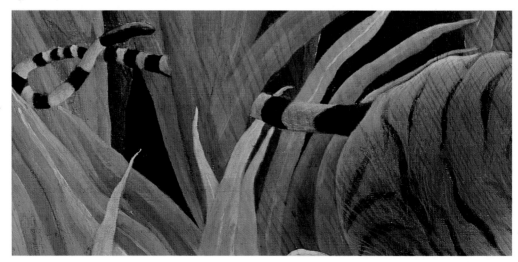

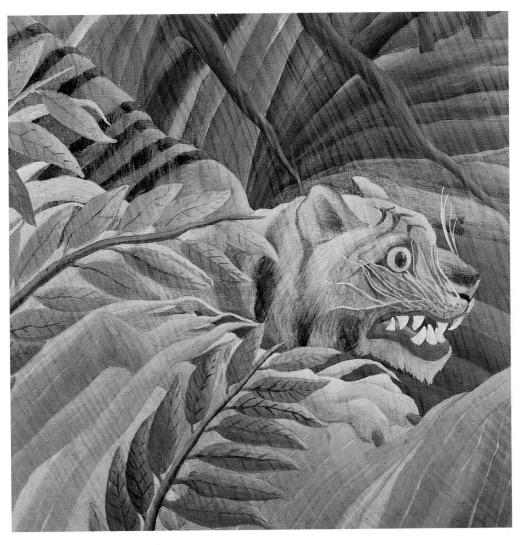

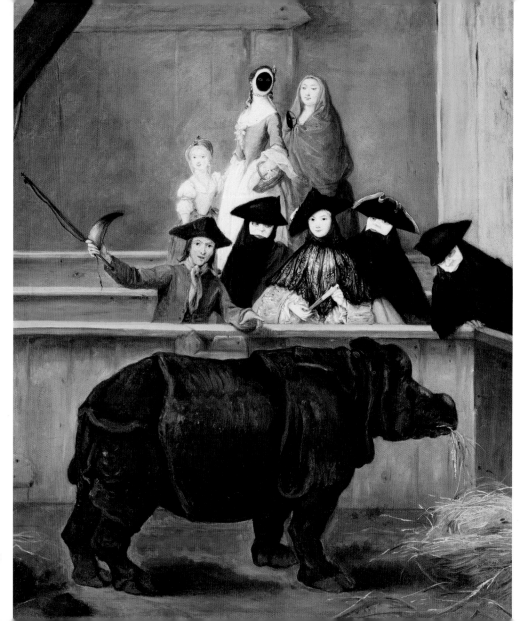

PIETRO LONGHI (1701–1785) Italian
*Exhibition of a Rhinoceros at Venice*
probably 1751

'Them that takes cakes
Which the Parsee-man bakes
Makes dreadful mistakes.'

And there was a great deal more in that than you would think.

  *Because*, five weeks later, there was a heatwave in the Red
Sea, and everybody took off all the clothes they had. The
Parsee took off his hat; but the Rhinoceros took off his skin
and carried it over his shoulder as he came down to the
beach to bathe. In those days it buttoned underneath with
three buttons and looked like a waterproof. He said nothing
whatever about the Parsee's cake, because he had eaten it
all; and he never had any manners, then, since, or hence-
forward. He waddled straight into the water and blew bub-
bles through his nose, leaving his skin on the beach.

  Presently the Parsee came by and found the skin, and he
smiled one smile that ran all round his face two times. Then
he danced three times round the skin and rubbed his hands.

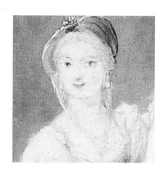

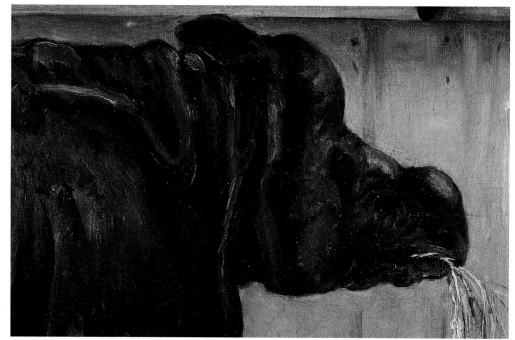

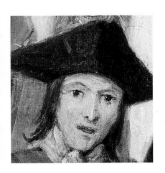

Then he went to his camp and filled his hat with cake-crumbs, for the Parsee never ate anything but cake, and never swept out his camp. He took that skin, and he shook that skin, and he scrubbed that skin, and he rubbed that skin just as full of old, dry, stale, tickly cake-crumbs and some burned currants ever it could *possibly* hold. Then he climbed to the top of his palm-tree and waited for the Rhinoceros to come out of the water and put it on.

And the Rhinoceros did. He buttoned it up with the three buttons, and it tickled like cake-crumbs in bed. Then he wanted to scratch, but that made it worse; and then he lay down on the sands and rolled and rolled and rolled, and every time he rolled the cake-crumbs tickled him worse and worse and worse. Then he ran to the palm-tree and rubbed and rubbed and rubbed himself against it. He rubbed so much and so hard that he rubbed his skin into a great fold over his shoulders, and another fold underneath, where the buttons used to be (but he rubbed the buttons off), and he rubbed some more folds over his legs. And it spoiled his temper, but it didn't make the least difference to the cake-crumbs. They were inside his skin and they tickled. So he went home, very angry indeed and horribly scratchy; and from that day to this every rhinoceros has great folds in his skin and a very bad temper, all on account of the cake-crumbs inside.

*How the Rhinoceros got his Skin,*
RUDYARD KIPLING, 1902

ROELANDT SAVERY (1576–1639) Flemish
*Orpheus*
1628

Come into animal presence
No man is so guileless as
the serpent. The lonely white
rabbit on the roof is a star
twitching its ears at the rain.
The llama intricately
folding its hind legs to be seated
not disdains but mildly
disregards human approval.
What joy when the insouciant
armadillo glances at us and doesn't
quicken his trotting
across the track into the palm brush.

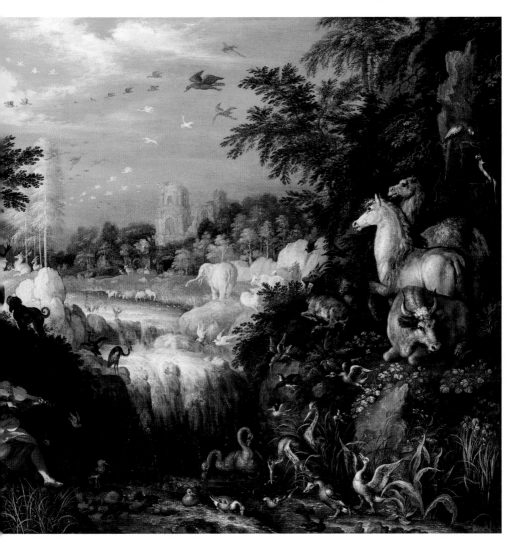

What is this joy? That no animal
falters, but knows what it must do?
That the snake has no blemish,
that the rabbit inspects his strange surroundings
in white star-silence? The llama
rests in dignity, the armadillo
has some intention to pursue in the palm-forest.
Those who were sacred have remained so,
holiness does not dissolve, it is a presence
of bronze, only the sight that saw it
faltered and turned from it.
An old joy returns in holy presence.

*Come into Animal Presence,*
DENISE LEVERTOV, 1966

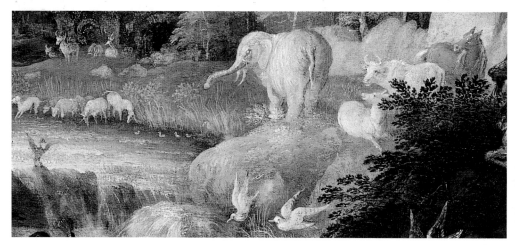

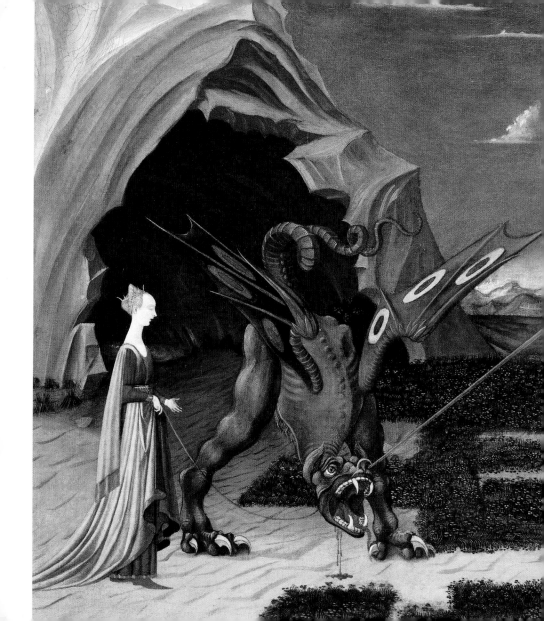

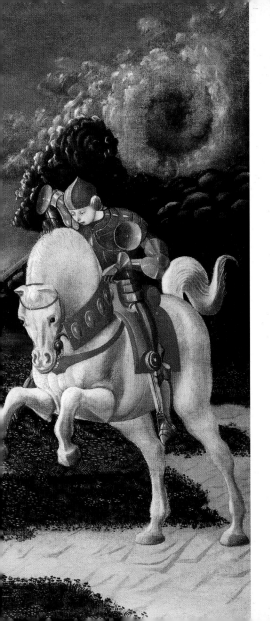

PAOLO UCCELLO (1397–1475) Italian
*Saint George and the Dragon*
about 1460

..."Save us from the dragon
Within the Black Wood!

' "Its head is a tiger's,
A lion's its jaw,
On six human feet
Are nailed the bear's claw.
As strong as a jail
Are the spikes on its shell,
Its tail a stout timber
No woodman can fell.

' "With the mane of a horse
And the frame of a bull,
Its teeth, swords and daggers
That no man can pull,
It swims in the fresh
And it swims in the brine
As landsmen and watermen,
Martha, know fine.

' "And many a traveller
Who sailed by our shore
Fell down the steep water
To rise up no more;
And many a soldier
Of many a fame
Rode out to the Black Wood
But home never came.

' "Ungathered our harvest
Our barns they are bare.
No man to the farm
Or the field may repair.
All swallowed our flocks
And our hope it is gone.
For food to our children
We give but a stone.

' "The temple fires burn
But no word the gods say,
Our sacrifice turning
To dust and to clay.
O Martha, good Martha,"
The Captain did cry,
"From the dragon deliver
Us all, or we die!" '

from *St Martha and the Dragon*,
CHARLES CAUSLEY, 1951

FOLLOWER OF GIORGIONE
*Homage to a Poet*
early 16th century

I think I could turn and live with animals, they are so placid
    and self-contained,
I stand and look at them sometimes an hour at a stretch.
They do not sweat and whine about their condition,
They do not lie awake in the dark and weep for their sins,
They do not make me sick discussing their duty to God,
No one is dissatisfied—not one is demented with the mania of
    owning things,
Not one kneels to another, nor to his kind that lived thousands
    of years ago,
Not one is respectable or industrious over the whole earth.

from *Song of Myself,*
WALT WHITMAN, 1855

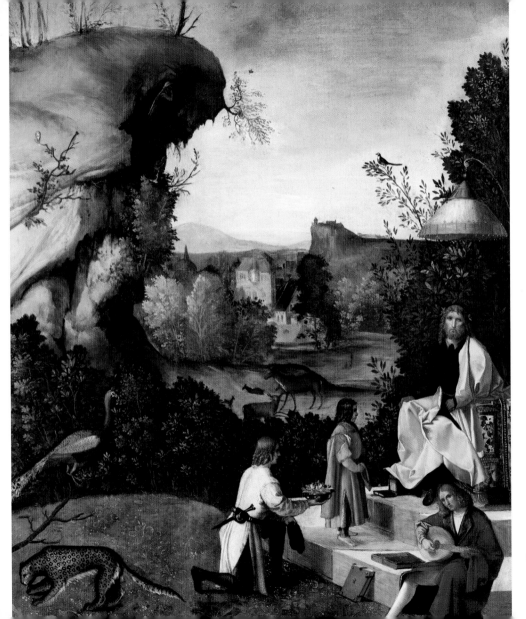

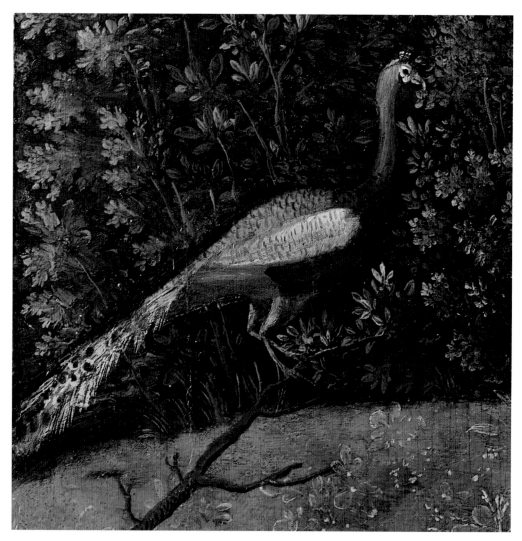

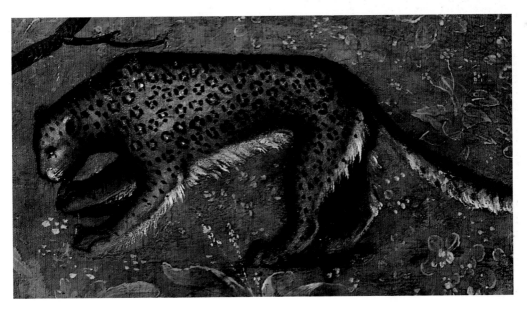

cherished

35

EDOUARD MANET (1832–1883) French
*Woman with a Cat*
about 1880–2

I was then two years old, and was at the same time the fattest and most naive cat in existence. At that tender age I still had all the presumptuousness of an animal who is disdainful of the sweetness of home.

How fortunate I was, indeed, that providence had placed me with your aunt!

That good woman adored me. I had at the bottom of a wardrobe a veritable sleeping salon, with feather cushions and triple covers. My food was equally excellent; never just bread, or soup, but always meat, carefully chosen meat.

Well, in the midst of all this opulence, I had only one desire, one dream, and that was to slip out of the upper window and escape onto the roofs. Caresses annoyed me, the softness of my bed nauseated me, and I was so fat that it was disgusting even to myself. In short, I was bored the whole day long just with being happy.

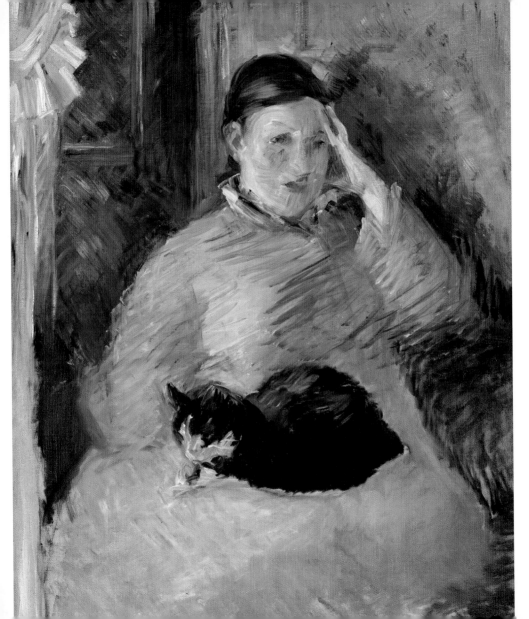

I must tell you that by stretching my neck a bit, I had seen the roof directly in front of my window. That day four cats were playing with each other up there; their fur bristling, their tails high, they were romping around with every indication of joy on the blue roof slates baked by the sun. I had never before watched such an extraordinary spectacle. And from then on I had a definitely fixed belief: out there on that roof was true happiness, out there beyond the window which was always closed so carefully. In proof of that contention I remembered that the doors of the chest in which the meat was kept were also closed, just as carefully! I resolved to flee. After all there had to be other things in life besides a comfortable bed.

from *The Cat's Paradise*,
EMILE ZOLA, 19th century

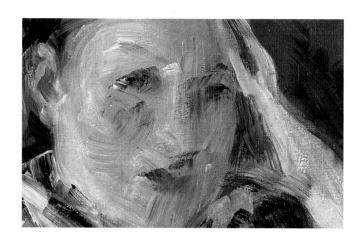

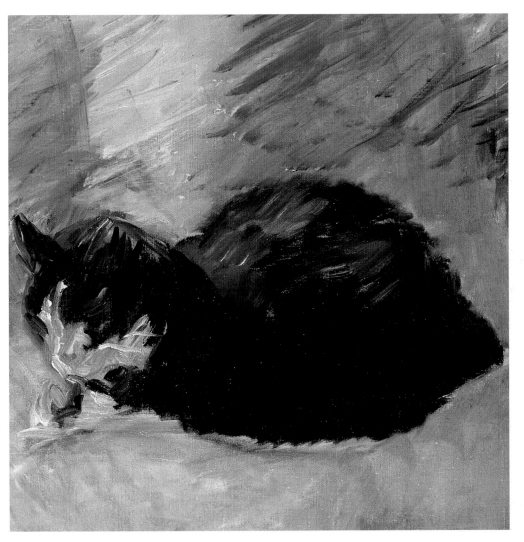

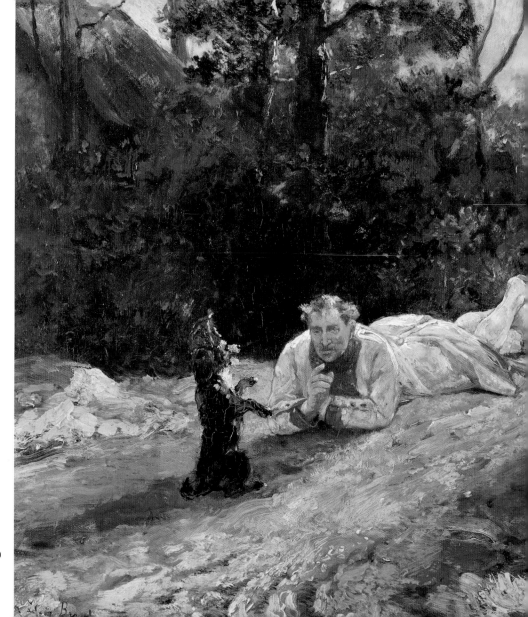

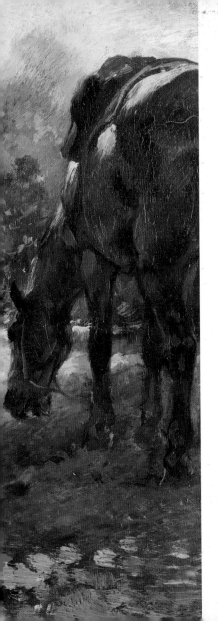

## JOHN LEWIS BROWN (1829–1890) French
### *The Performing Dog*
probably about 1860–90

I received the following narrative from the old man who had been so long known about the streets of London with a troop of performing dogs. He was especially picturesque in his appearance. His hair, which was grizzled rather than grey, was parted down the middle, and hung long and straight over his shoulders. He was dressed in a coachman's blue greatcoat with many capes. His left hand was in a sling made out of a dirty pocket-handkerchief and in his other he held a stick, by means of which he could just manage to hobble along. He was very ill, and very poor, not having been out with his dogs for nearly two months. He appeared to speak in great pain. The civility, if not politeness of his manner, threw an air of refinement about him, that struck me more forcibly from its contrast with the manners of the English belonging to the same class. He began—

"I have de dancing dogs for de street—now I have nothing else. I have tree dogs—one is called Finette, anoder von Favorite, that is her nomme, an de oder von Ozor. Ah I," he said, with a shrug of the shoulders, in answer to my inquiry as to what the dogs did, "un danse, un valse, un jomp a de

stick and troo do hoop—non, noting else. Sometimes I had de four dogs—I did lose de von. Ah! she had beacoup d'esprit—plenty of vit, you say—she did jomp a de hoop better dan all. Her nomme was Taborine!—she is dead dare is long time. All ma dogs have des habillements—the dress and de leetle hat. Ey have a leetle jackettes in divers colours en etoffe—some de red, and some de green, and some de bleu. Deir hats is de rouge et noir—red and black, with a leetle plume—fedder, you say. Dare is some 10 or 11 year I have been in dis country.

from *London Labour and the London Poor,*
HENRY MAYHEW, 1851

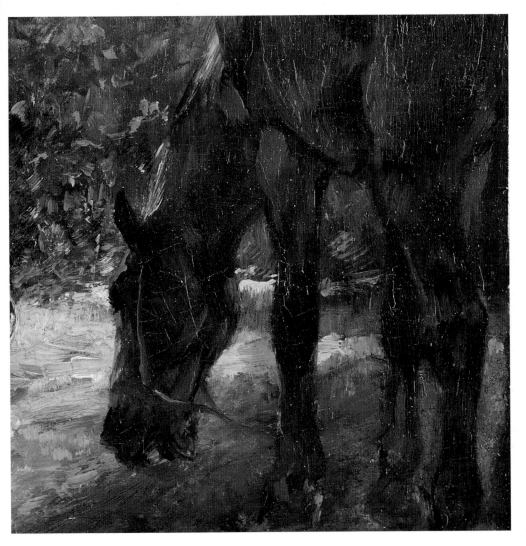

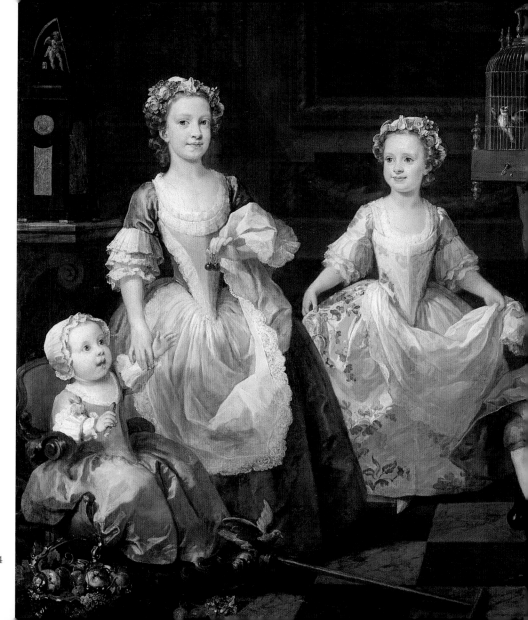

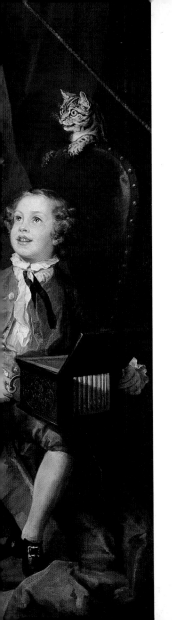

WILLIAM HOGARTH (1697–1764) English
*The Graham Children*
1742

She sights a Bird—she chuckles—
She flattens—then she crawls—
She runs without the look of feet—
Her eyes increase to Balls—

Her Jaws stir—twitching—hungry—
Her Teeth can hardly stand—
She leaps, but Robin leaped the first—
Ah, Pussy, of the Sand,

The Hopes so juicy ripening—
You almost bathed your Tongue—
When Bliss disclosed a hundred Toes—
And fled with every one—

*She Sights a Bird,*
EMILY DICKINSON, 1862

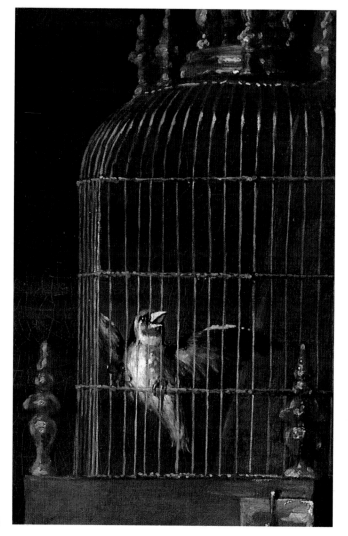

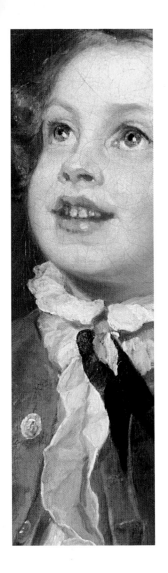
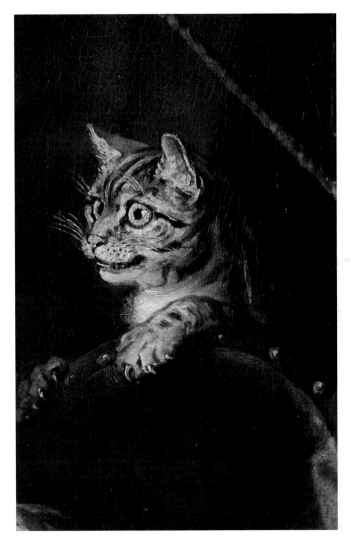

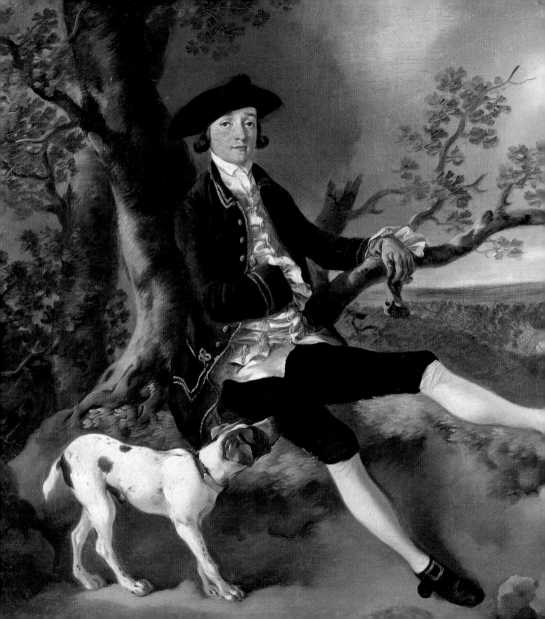

THOMAS GAINSBOROUGH (1727–1788)
English
*John Plampin*
about 1752

Who's this—alone with stone and sky?
It's only my old dog and I—
It's only him; it's only me;
Alone with stone and grass and tree.

What share we most—we two together?
Smells, and awareness of the weather.
What is it makes us more than dust?
My trust in him; in me his trust.

Here's anyhow one decent thing
That life to man and dog can bring;
One decent thing, remultiplied
Till earth's last dog and man have died.

*Man and Dog,*
SIEGFRIED SASSOON, *c.* 1960

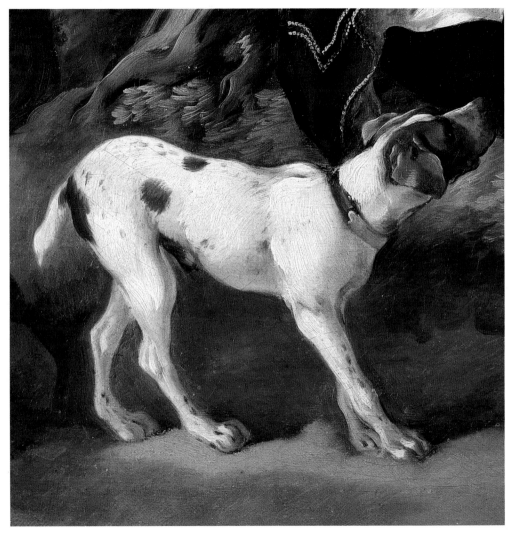

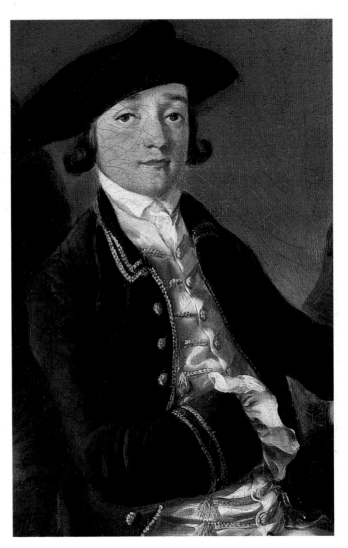

JEAN-BAPTISTE PERRONNEAU (1715?–1783) French
*A Girl with a Kitten*
1745

I like little pussy, her coat is so warm,
And if I don't hurt her, she'll do me no harm.
So I'll not pull her tail, nor drive her away,
But pussy and I very gently will play,
She shall sit by her side and I'll give her some food;
And she'll love me because I am gentle and good.

I'll pat pretty pussy, and then she will purr;
And thus show her thanks for my kindness to her.
But I'll not pinch her ears, nor tread on her paw,
Lest I should provoke her to use her sharp claw.
I never will vex her, nor make her displeased—
For pussy don't like to be worried and teased.

*Pussy,*
ANONYMOUS, *c.* 1830

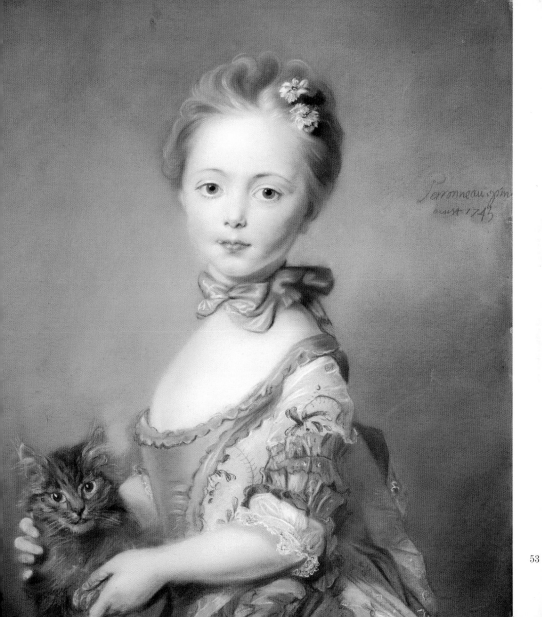

53

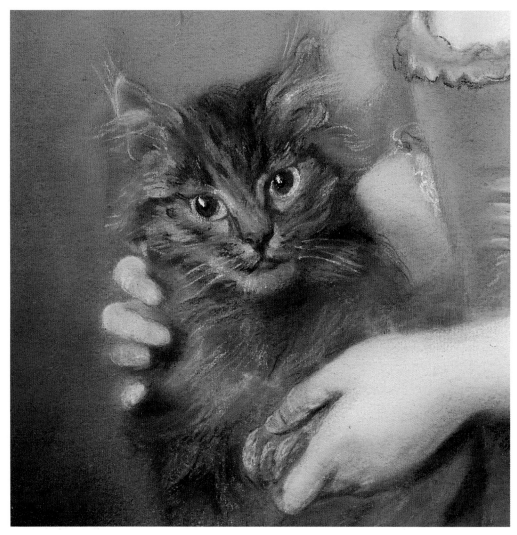

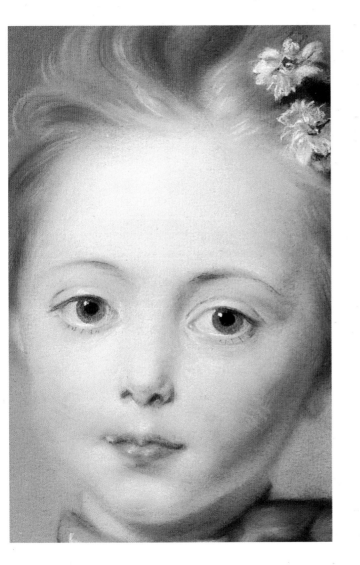

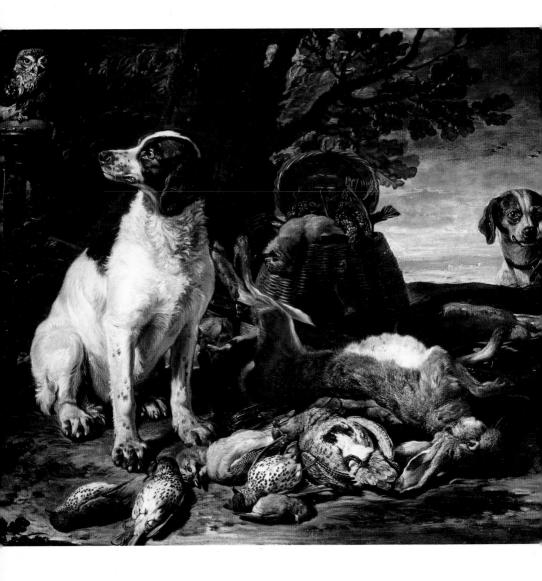

DAVID DE CONINCK (1643/5–1699 or later) Netherlandish
*Dead Birds and Game with Gun Dogs and a Little Owl*
probably about 1672–94

See how the well-taught pointer leads the way;
The scent grows warm; he stops; he springs the prey;
The fluttering coveys from the stubble rise,
And on swift wing divide the sounding skies;
The scattering lead pursues the certain sight,
And death in thunder overtakes their flight…

As in successive Toil the Seasons roll,
So various Pleasures recreate the Soul
The setting Dog, instructed to betray,
Rewards the Fowler with the Feather'd Prey.
Soon as the lab'ring Horse with swelling veins,
Hath safely hous'd the Farmer's doubtful Gains,
To sweet Repast th'unwary Partridge flies,
At Ease amidst the scatter'd Harvest lies,
Wand'ring in Plenty, Danger he forgets,
Nor dreads the Slav'ry of entangling Nets.

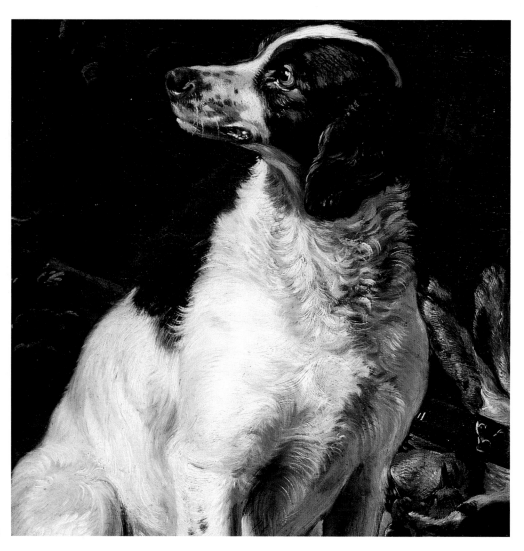

The subtle Dog with sagacious nose
Scowres through the Field, and snuffs each Breeze that blows,
Against the wind he takes his prudent way,
While the strong Gale directs him to the Prey
Now the warm Scent assures the Covey near,
He treads with caution, and he points with Fear
Then lest some Sentry Fowl his Fraud descry,
And bid his Fellows from the Danger fly,
Close to the Ground in Expectation lies,
Till in the snare the fluttering Covey rise,
And on swift wing divide the sounding skies;
The scatt'ring lead pursues the certain sight,
And death in thunder overtakes the flight.

from *Rural Sports,*
JOHN GAY, *c.* 1713

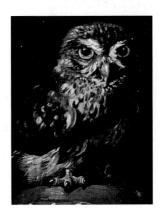

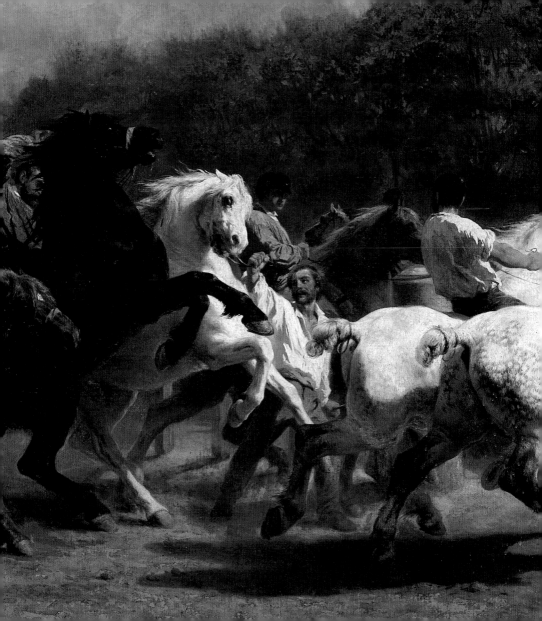

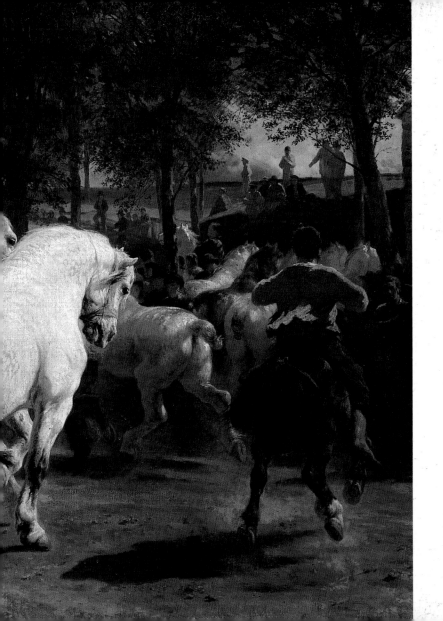

noble

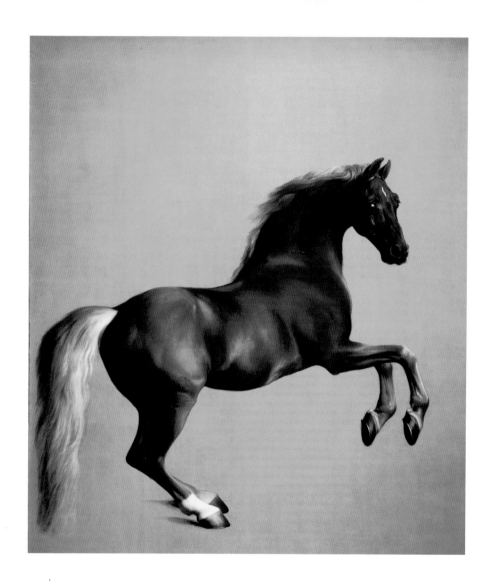

GEORGE STUBBS (1724–1806) English
*Whistlejacket*
1762

There's more intelligence and beauty in the horse's face.
He hears the talk of leaves and stones.
Intent, he knows the animal's cry
And the nightingale's murmur in the copse.

And knowing all, to whom may he recount
His wonderful visions?
The night is hushed. In the dark sky
Constellations rise.
The horse stands like a knight keeping watch,
The wind plays in his light hair,
His eyes burn like two huge worlds,
And his mane lifts like the imperial purple.

And if a man should see
The horse's magical face,
He would tear out his own impotent tongue
And give it to the horse. For
This magical creature is surely worthy of it.

Then we should hear words.
Words large as apples. Thick
As honey or buttermilk.
Words which penetrate like flame
And, once within the soul, like fire in
    some hut,
Illuminate its wretched trappings.
Words which do not die
And which we celebrate in song.

from *The Face of a Horse,*
NIKOLAY ALEKSEEVICH ZABOLOTSKY, 1926

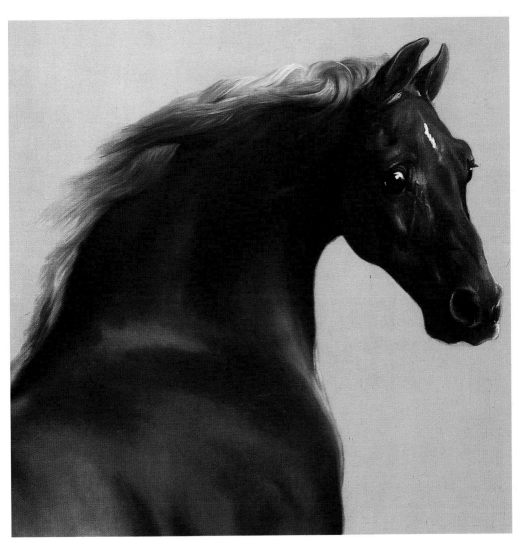

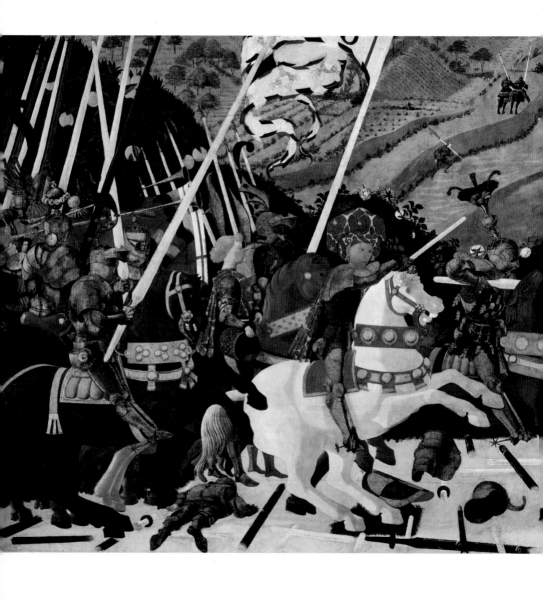

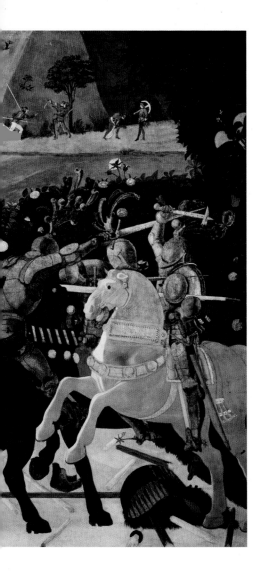

PAOLO UCCELLO (1397–1475) Italian
*The Battle of San Romano*
probably about 1450–60

Whenever the horse stopped (which it did often), he fell off in front; and whenever it went on again (which it generally did rather suddenly), he fell off behind. Otherwise he kept on pretty well, except that he had a habit of now and then falling off sideways and, as he generally did this on the side on which Alice was walking, she soon found that it was the best plan not to walk *quite* close to the horse.

"I'm afraid you've not had much practice in riding," she ventured to say as she was helping him up from his fifth tumble.

The Knight looked very much surprised, and a little offended at the remark. "What makes you say that?" he asked, as he scrambled back into the saddle, keeping hold of Alice's hair with one hand, to save himself from falling over on the other side.

"Because people don't fall off quite so often, when they've had much practice."

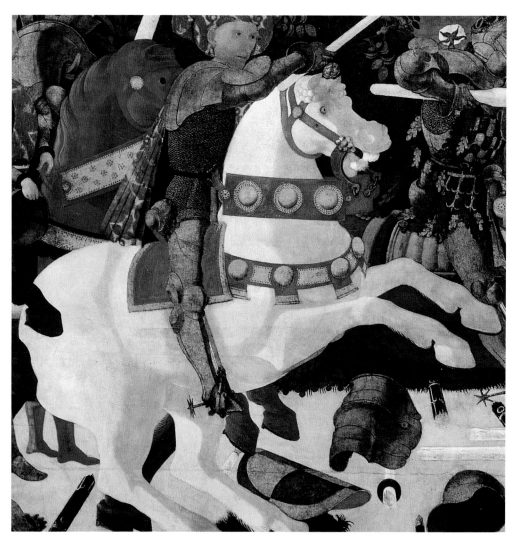

"I've had plenty of practice," the Knight said very gravely: "plenty of practice!"

Alice could think of nothing better to say than "Indeed?", but she said it as heartily as she could. They went on a little way in silence after this, the Knight with his eyes shut, muttering to himself, and Alice watching anxiously for the next tumble.

"The great art of riding," the Knight suddenly began in a loud voice, waving his right arm as he spoke, "is to keep—" Here the sentence ended as suddenly as it had begun, as the Knight fell heavily on the top of his head exactly in the path where Alice was walking. She was quite frightened this time, and said in an anxious tone, as she picked him up, "I hope no bones are broken?"

"None to speak of," the Knight said, as if he didn't mind breaking two or three of them. "The great art of riding, as I was saying, is—to keep your balance properly. Like this you know—"

He let go the bridle, and stretched out both his arms to show Alice what he meant, and this time he fell flat on his back, right under the horse's feet.

"Plenty of practice!" he went on repeating, all the time that Alice was getting him on his feet again. "Plenty of practice!"

"It's too ridiculous!"' cried Alice, losing all her patience this time. "You ought to have a wooden horse on wheels, that you ought!"

*Through the Looking Glass,*
LEWIS CARROLL, 1872

ANTHONY VAN DYCK (1599–1641) Flemish
*Equestrian Portrait of Charles I*
about 1637–8

Then the Lord answered Job out of the whirlwind…
Hast thou given the horse strength?
Has thou clothed his neck with thunder?
Canst thou make him afraid as a grasshopper?
The glory of his nostrils is terrible.
He paweth in the valley, and rejoiceth in his strength:
He goeth on to meet the armed men.
He mocketh at fear, and is not affrighted;
Neither turneth he back from the sword.
The quiver rattleth against him,
The glittering spear and the shield.
He swalloweth the ground with fierceness and rage:
Neither believeth he that he is the sound of the
trumpet.
He saith among the trumpets, ha, ha;
And he smelleth the battle afar off
The thunder of the captains, and the shouting.

JOB 39: 19–25

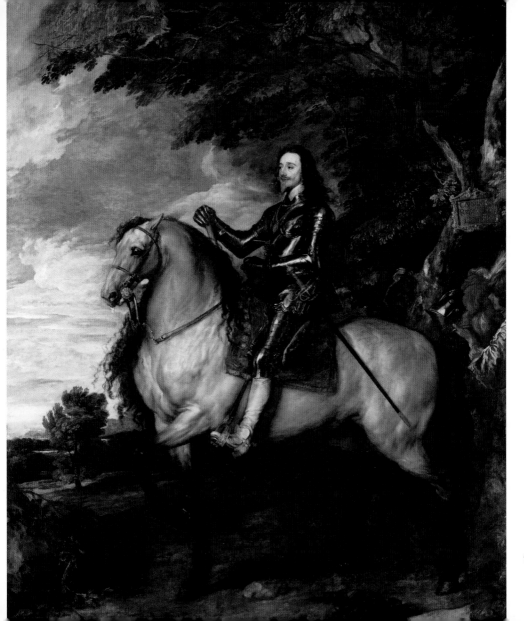

71

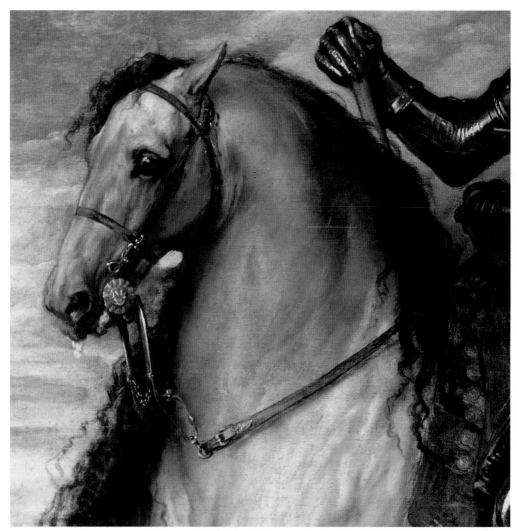

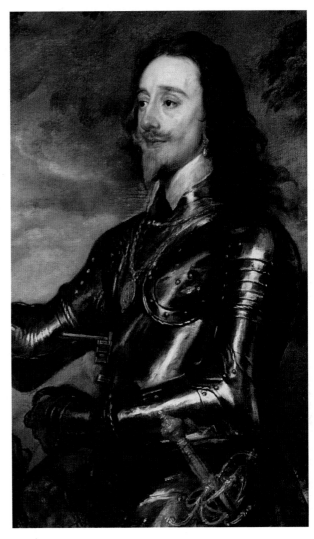

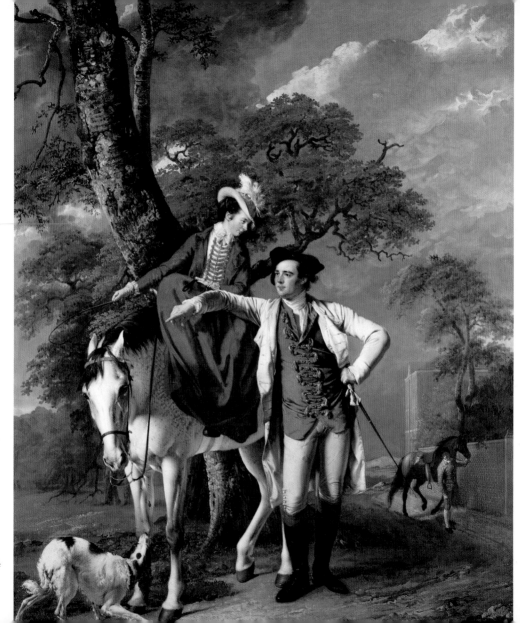

JOSEPH WRIGHT OF DERBY (1734–1797) English

*Mr and Mrs Thomas Coltman*
about 1770–2

| | |
|---|---|
| GEORGINA | Oh what a day for riding, |
| LADY GRIG | For riding on a horse |
| SIR GREGORY | Over the Yorkshire Ridings |
| DOWAGER | On a horse, of course. |
| GEORGINA | Oh what a day for riding |
| SIR GREGORY | And givin' young blackguards a hiding |
| LADY GRIG | With a horsewhip for their sauce. |
| GEORGINA | Oh what a day for a hiding |
| DOWAGER | With a horsewhip of course |
| GEORGINA | Oh what a day for hunting, |
| LADY GRIG | Hunting the fox on a horse. |
| SIR GREGORY | Can't you hear the sound |
| GEORGINA | Of horse and hound? |
| SIR GREGORY | View Haloo! |
| GEORGINA | And gone to ground! |
| DOWAGER | Hunting the fox of course. |
| SIR GREGORY | Oh what a day for hunting! |
| GEORGINA | All of us in the pink. |
| SIR GREGORY | Oh by Pegasus! |
| DOWAGER | Oh by Bucephalus! |
| GEORGINA | After a lashing of drink. |
| SIR GREGORY | O think of the pink of the huntsman's coat |
| DOWAGER | And the cherry red of his nose, |
| GEORGINA | The stirrup-cup rounds |

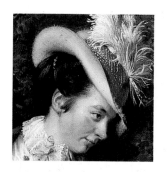

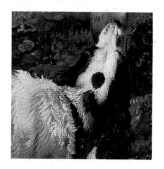

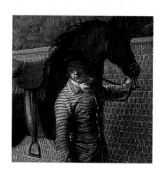

| SIR GREGORY | And the Master of Hounds |
| LADY GRIG | And the horrible noise he blows. |
| GEORGINA | Oh what a day for hunting! |
| DOWAGER | Oh fetlocks and withers and hocks! |
| SIR GREGORY | Oh think of the thrill |
| GEORGINA | Of the chase and the kill… |
| LADY GRIG | And think of the thrill to the fox. |

(song continues)

| GEORGINA | Oh, what a day for driving, |
| LADY GRIG | For driving in a gig, |
| SIR GREGORY | Clippety clop, |
| DOWAGER | See the clodhoppers hop, |
| SIR GREGORY | At the sight of Sir Gregory Grig. |

(song continues)

SIR GREGORY Oh what a day for driving
For driving in a gig
To whet your morning whistle,
In the Rose and Thistle,
But *not* with Sir Gregory Grig.

Oh, what a day for hunting,
Hunting on a horse,
Over the fields and into the town,
And into the bar of the Rose and Crown…

from *Me & My Bike*,
DYLAN THOMAS, 1948

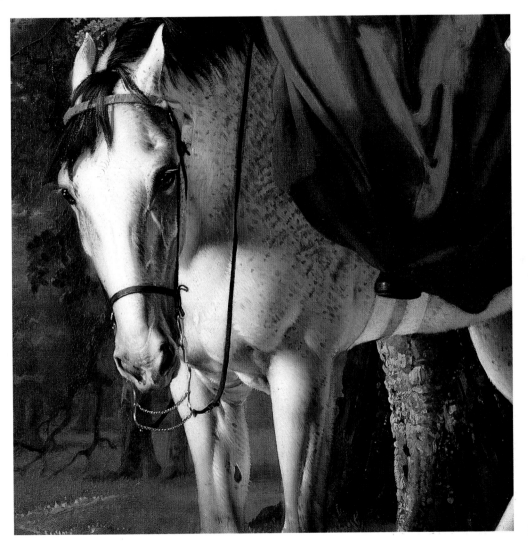

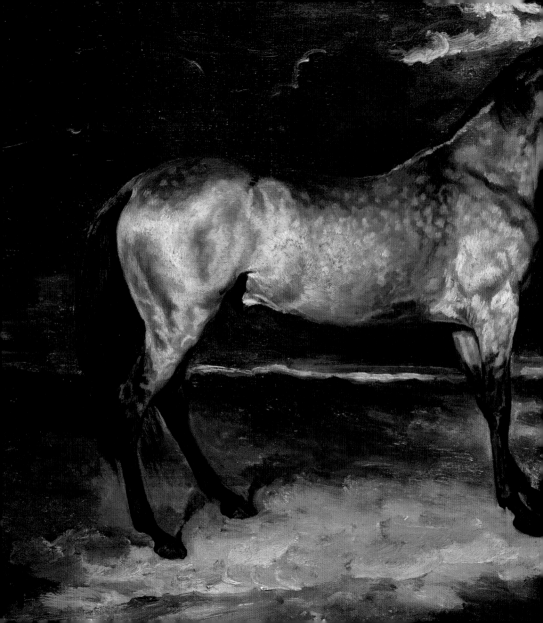

### Jean-Louis-André-Théodore Géricault
### (1791–1824) French

*A Horse frightened by Lightning*
about 1813–14

Storm-clouds hurtle, storm-clouds hover;
Flying snow is set alight
By the moon whose form they cover;
Blurred the heavens, blurred the night.
We can't whirl so any longer!
Suddenly, the bell has ceased,
Horses halted... —Hey, what's wrong there?
"Who can tell!—a stump? a beast?"

Blizzard's raging, blizzard's crying,
Horses panting, seized by fear;
Far away his shape is flying;
Still in haze the eyeballs glare;
Horses pull us back in motion,
Little bell goes din-din-din...
I behold a strange commotion:
Evil spirits gather in—

Sundry, ugly devils, whirling
In the moonlight's milky haze:
Swaying, flittering and swirling
Like the leaves in autumn days...
What a crowd! Where are they carried?
What's the plaintive song I hear?
Is a goblin being buried,
Or a sorceress married there?

Storm-clouds hurtle, storm-clouds hover;
Flying snow is set alight
By the moon whose form they cover;
Blurred the heavens, blurred the night.
Swarms of devils come to rally,
Hurtle in the boundless height;
Howling fills the whitening valley,
Plaintive screeching rends my heart...

*Devils,*
ALEXANDER SERGEYEVICH PUSHKIN, 1830

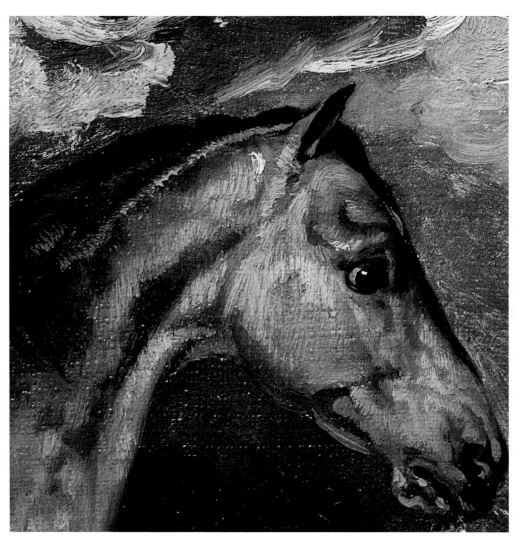

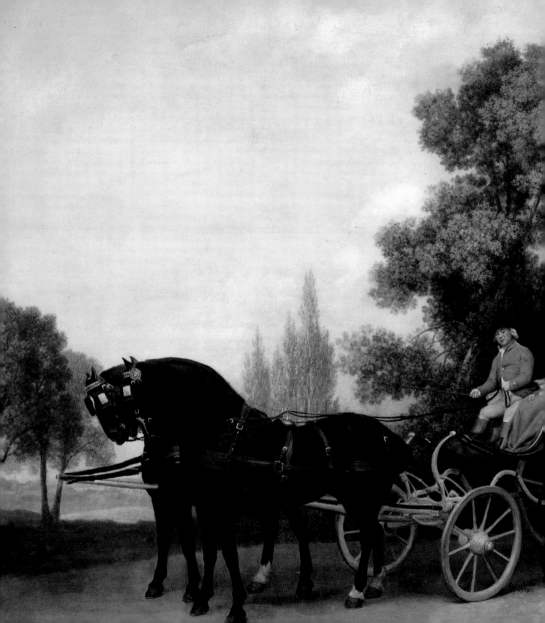

GEORGE STUBBS (1724–1806) English
*A Gentleman driving a Lady in a Phaeton*
1787

In the afternoon we were harnessed and put in the carriage, and as the stable clock struck three we were led round to the front of the house. It was all very grand, and three or four times as large as the old house at Birtwick, but not half so pleasant, if a horse may have an opinion. Two footmen were standing ready, dressed in drab livery, with scarlet breeches and white stockings.

Presently we heard the rustling sound of silk as my lady came down the flight of stone steps. She stepped around to look at us; she was a tall, proud-looking woman, and did not seem pleased about something, but she said nothing, and got into the carriage. This was the first time of wearing a bearing rein, and I must say, though it certainly was a nuisance not to be able to get my head down now and then, it did not pull my head higher than I was accustomed to carry it. I felt anxious about Ginger, but she seemed to be quiet and content.

The next day at three o'clock we were again at the door, and the footmen as before; we heard the silk dress rustle, and the lady came down the steps, and in an imperious voice she said, "York, you must put those horses' heads higher; they are not fit to be seen."

from *Black Beauty*,
ANNA SEWELL, 1877

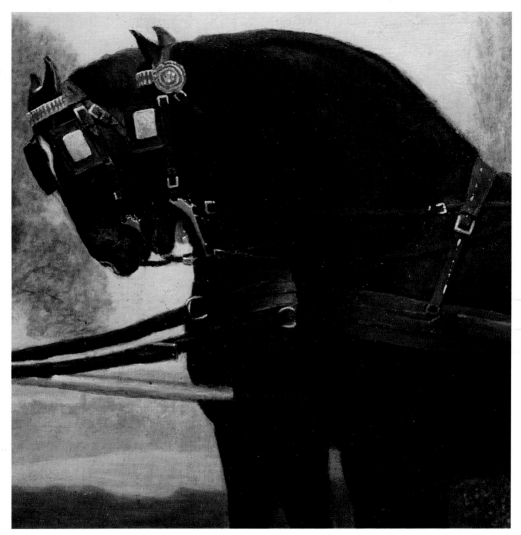

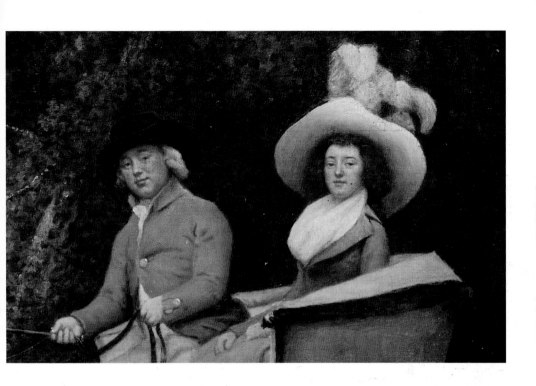

STYLE OF VAN DYCK
*The Horses of Achilles*
about 1650–1725

I hear the Shadowy Horses, their long manes a-shake,
Their hoofs heavy with tumult, their eyes glimmering white;
The North unfolds above them clinging, creeping night,
The East her hidden joy before the morning break,
The West weeps in pale dew and sighs passing away,
The South is pouring down roses of crimson fire:
O vanity of Sleep, Hope, Dream, endless Desire,
The Horses of Disaster plunge in the heavy clay:
Beloved, let your eyes half close, and your heart beat
Over my heart, and your hair fall over my breast,
Drowning love's lonely hour in deep twilight of rest,
And hiding their tossing manes and their tumultuous feet.

*He Bids His Beloved Be at Peace,*
WILLIAM BUTLER YEATS, 1899

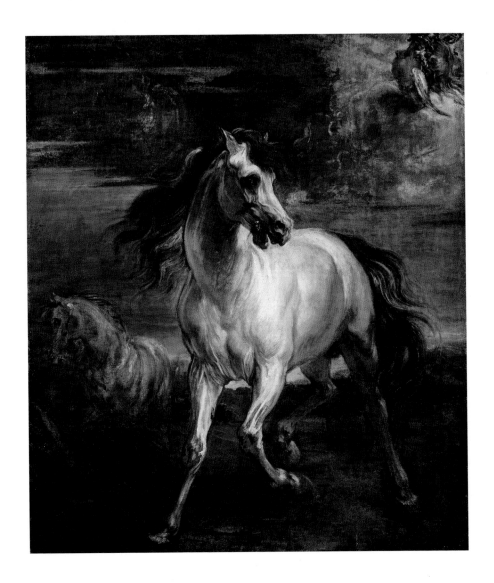

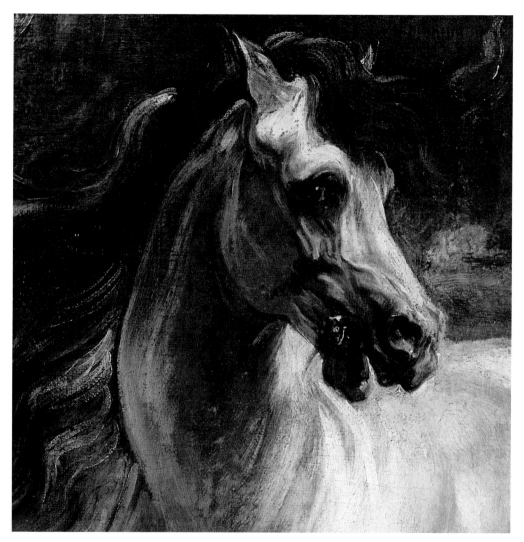

humble

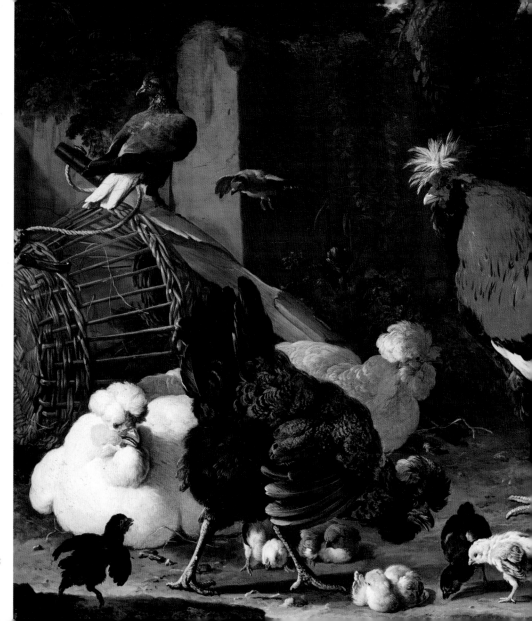

MELCHIOR D'HONDECOETER (1636–1695)
Dutch
*A Cock, Hens and Chicks*
about 1668–70

Before the barn door crowing
The cock by hens attended,
His eyes around him throwing,
Stands for a while suspended;
Then one he singles from the crew,
And cheers the happy hen,
With how do you do, and how do you do,
And how do you do again.

from *Fables,*
JOHN GAY, 1738

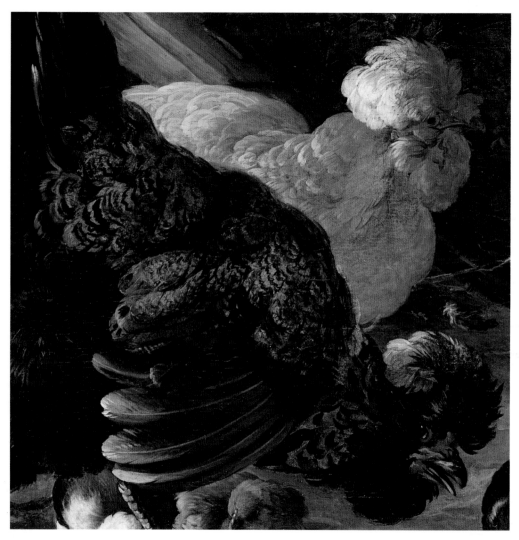

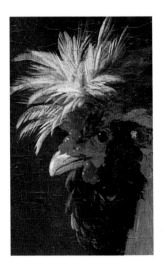

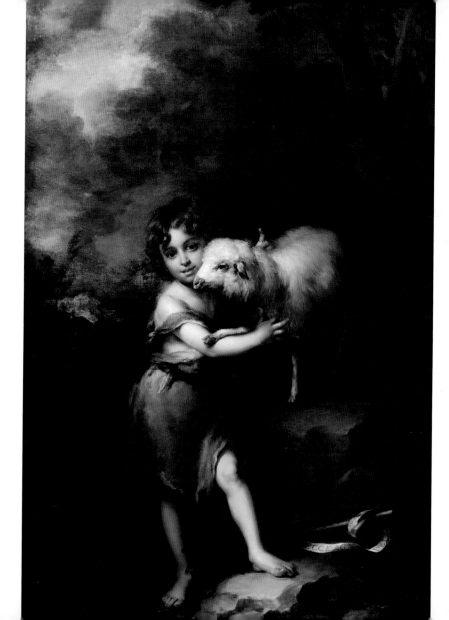

BARTOLOMÉ ESTEBAN MURILLO
(1617–1682) Spanish
*The Infant Saint John with the
Lamb*
1600–5

Little Lamb, who made thee
  Dost thou know who made thee
Gave thee life & bid thee feed,
By the stream & o'er the mead;
Gave thee clothing of delight,
Softest clothing wooly bright;
Gave thee such a tender voice,
Making all the vales rejoice;
  Little Lamb, who made thee
  Dost thou know who made thee

Little Lamb I'll tell thee,
  Little Lamb I'll tell thee;
He is called by thy name,
For he calls himself a Lamb:
He is meek & he is mild,
He became a little child;
I a child & thou a lamb,
We are called by his name.
  Little Lamb, God bless thee
  Little Lamb, God bless thee.

*The Lamb,*
WILLIAM BLAKE, 1789

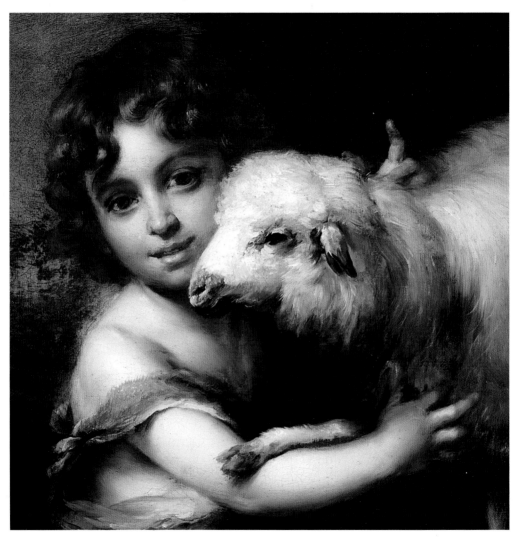

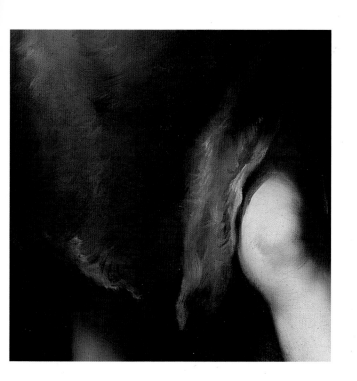

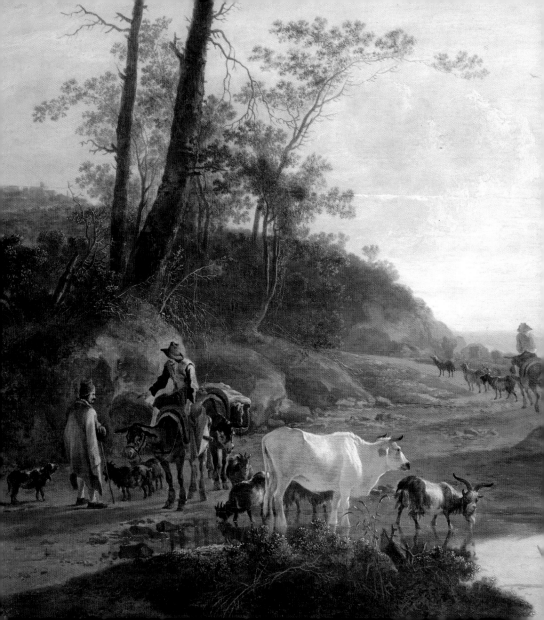

JAN BOTH (about 1615–1652) Dutch
*Muleteers, and a Herdsman with an Ox and Goats by a Pool*
about 1645

Touching a subtil pranke and witty tricke, is there any so
famous as that of *Thales,* the Philosophers mule, which, laden
with salt, passing thorow a River chanced to stumble, so that
the sacks she carried were all wet, and perceiving the salt
(because the water had melted it) to grow lighter, ceased not,
assoone as she came neare any water, together with her load
to plunge herselfe therein, untill her master, being aware of
her craft, commanded her to be laden with wooll, which being
wet became heavier; the Mule finding herselfe deceived, used
her former policy no more.

*Astute Mule,*
MONTAIGNE, 16th century

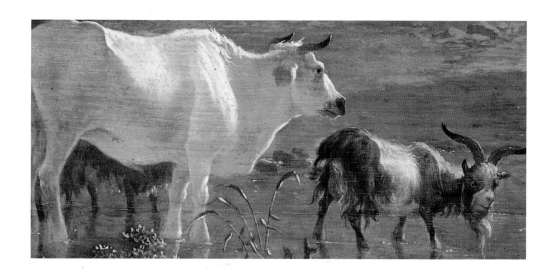

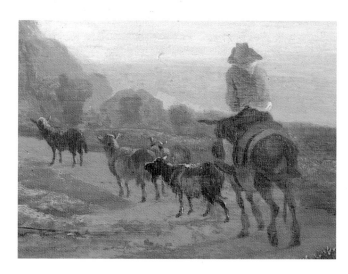

102

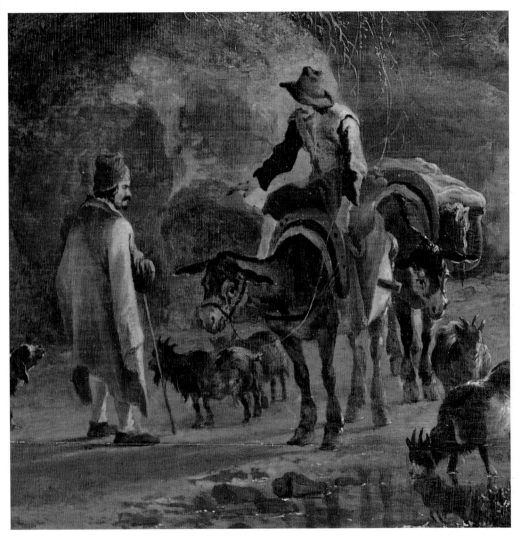

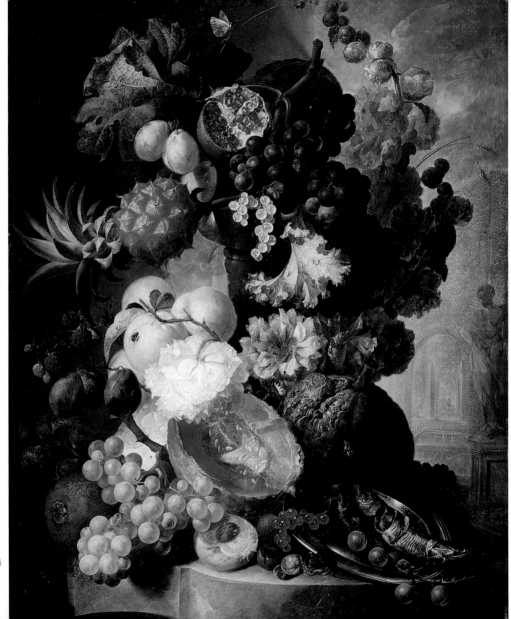

JAN VAN OS (1744–1808) Dutch
*Fruit, Flowers and a Fish*
1772

Christmas and Easter may be feasts
For congregations and for priests,
And so may Whitsun. All the same,
They do not fill my meagre frame...

Within the human world I know
Such goings-on could not be so,
For human beings only do
What their religion tells them to.
They read the Bible every day
And always, night and morning, pray,
And just like me, the good church mouse,
Worship each week in God's own house.

But all the same it's strange to me
How very full the church can be
With people I don't see at all
Except at Harvest Festival.

from *Diary of a Church Mouse,*
JOHN BETJEMAN, 1954

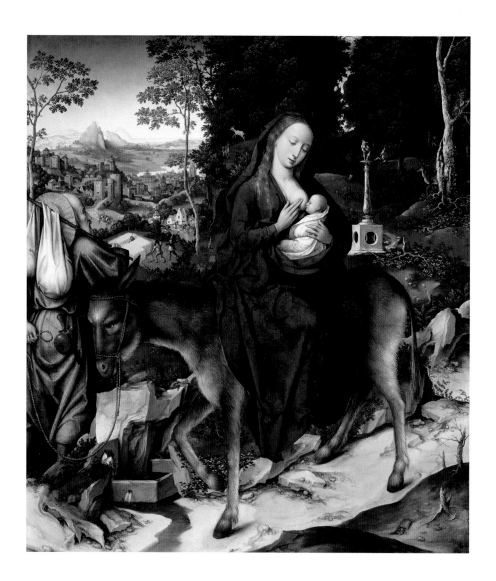

WORKSHOP OF THE MASTER OF 1518
*The Flight into Egypt*
about 1515

When I must come to you, O my God, I pray
It be some dusty-roaded holiday,
And even as in my travels here below,
I beg to choose by what road I shall go
To Paradise, where the clear stars shine by day.
I'll take my walking-stick and go my way,
And to my friends the donkeys I shall say,
'I am Francis Jammes, and I'm going to Paradise,
For there is no hell in the land of the loving God.'
And I'll say to them: 'Come, sweet friends of the blue skies,
Poor creatures who with a flap of the ears or a nod
Of the head shake off the buffets, the bees, the flies…'

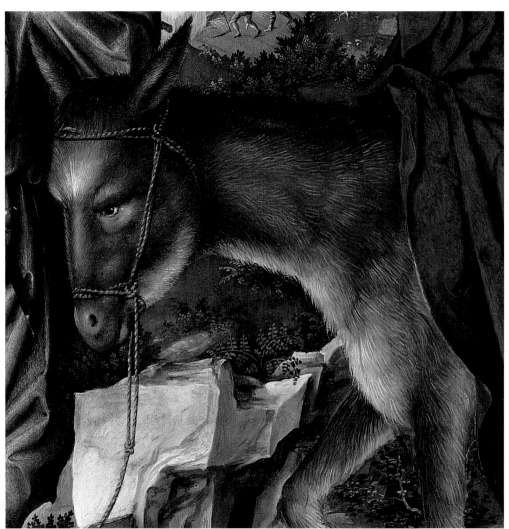

Let me come with these donkeys, Lord, into your land,
These beasts who bow their heads so gently, and stand
With their small feet joined together in a fashion
Utterly gentle, asking your compassion.
I shall arrive, followed by their thousands of ears,
Followed by those with baskets at their flanks,
By those who lug the carts of mountebanks
Or loads of feather-dusters and kitchen-wares,
By those with humps of battered water-cans,
By bottle-shaped she-asses who halt and stumble,
By those tricked out in little pantaloons
To cover their wet, blue galls where flies assemble
In whirling swarms, making a drunken hum.
Dear God, let it be with these donkeys that I come,
And let it be that angels lead us in peace
To leafy streams where cherries tremble in air,
Sleek as the laughing flesh of girls; and there
In that haven of souls let it be that, leaning above
Your divine waters, I shall resemble these donkeys,
Whose humble and sweet poverty will appear
Clear in the clearness of your eternal love.

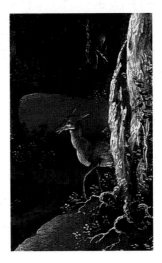

*A Prayer to Go to Paradise with the Donkeys,*
FRANCIS JAMMES, early 20th century

JOHANNES SPRUYT
(1627/8–1671) Dutch
*Geese and Ducks*
probably about 1660

I
From troubles of the world
 I turn to ducks,
Beautiful comic things
Sleeping or curled
Their heads beneath white wings
By water cool,
Or finding curious things
To eat in various mucks
Beneath the pool,
Tails uppermost, or waddling
Sailor-like on the shores
Of ponds, or paddling
—Left! right—with fanlike feet
Which are for steady oars
When they (white galleys) float
Each bird a boat
Rippling at will the sweet
Wide waterway…
When night is fallen *you* creep
Upstairs, but drakes and dillies
Nest with pale water-stars,
Moonbeams and shadow bars,

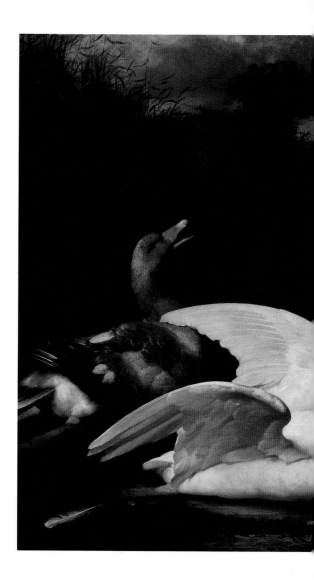

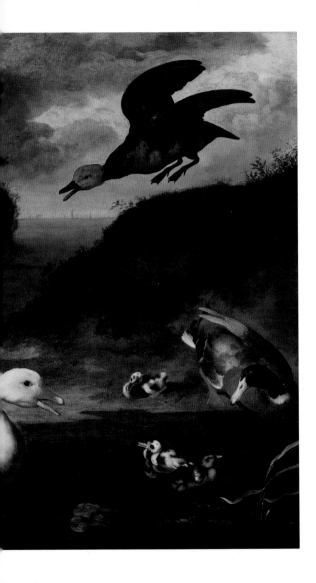

And water-lilies:
Fearful too much to sleep
Since they've no locks
To click against the teeth
Of weasel and fox.
And warm beneath
Are eggs of cloudy green
Whence hungry rats and lean
Would stealthily suck
New life, but for the mien,
The bold ferocious mien
Of the mother-duck.

II
Yes, ducks are valiant things
On nests of twigs and straws,
And ducks are soothy things
And lovely on the lake
When that the sunlight draws
Thereon their pictures dim
In colours cool.
And when beneath the pool
They dabble, and when they swim
And make their rippling rings,
O ducks are beautiful things!

from *Ducks*,
FREDERICK WILLIAM HARVEY, 1919

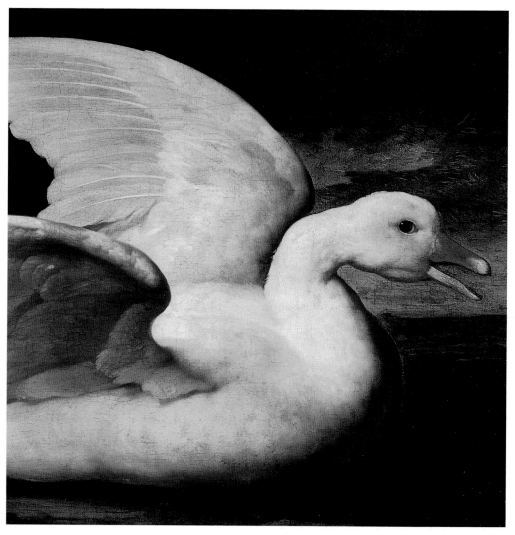

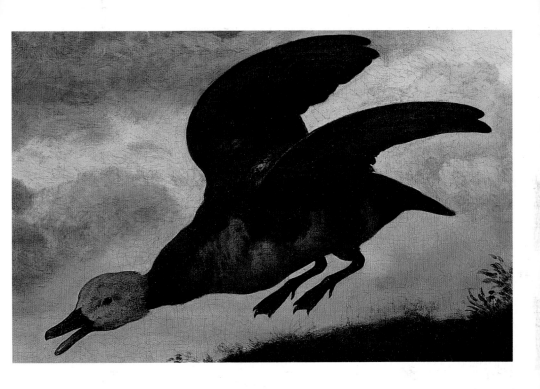

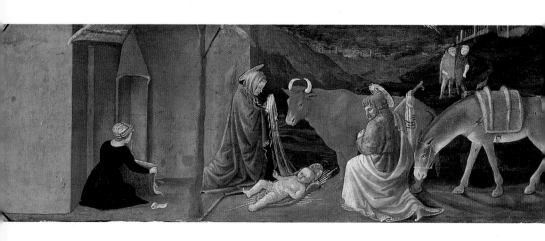

Master of the Castello Nativity
(active mid-15th century) Italian
*The Nativity*
perhaps about 1460

'Christmas Eve, and twelve of the clock,
Now they are all on their knees,'
An elder said as we sat in a flock
By the embers in hearthside ease.

We pictured the meek mild creatures where
They dwelt in their strawy pen,
Nor did it occur to one of us there
To doubt they were kneeling then.

So fair a fancy few would weave
In these years! Yet, I feel,
If someone said on Christmas Eve,
'Come; see the oxen kneel

'In the lonely barton by yonder coomb
Our children used to know,'
I should go with him in the gloom,
Hoping it might be so.

*The Oxen,*
Thomas Hardy, 1915

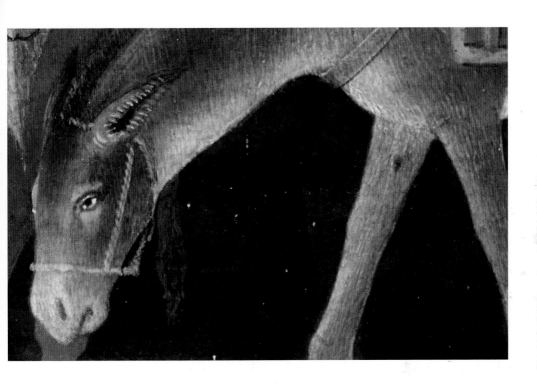

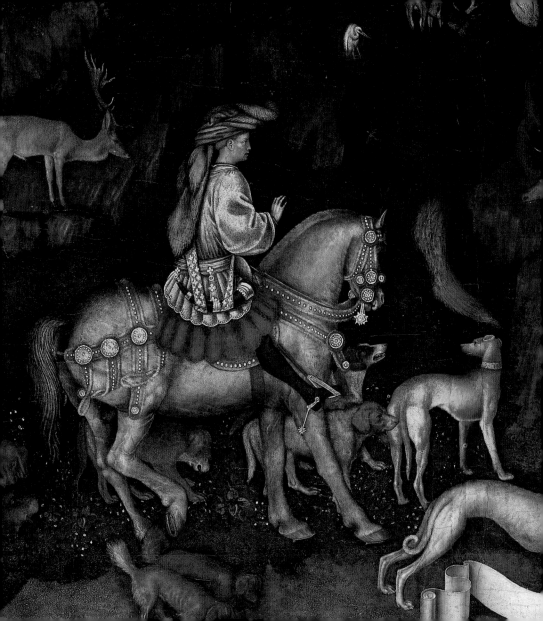

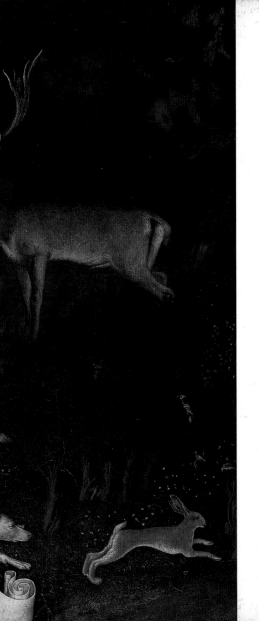

wild

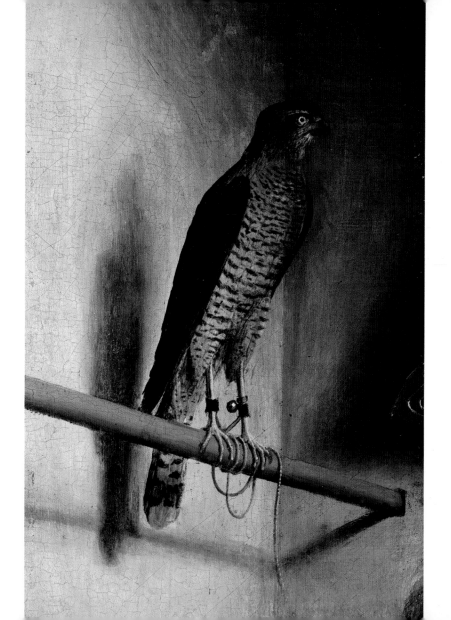

JACOPO DE' BARBARI (active 1500; died 1516?)
Possibly Italian
*A Sparrowhawk*
1510s

Next came the Hawk, with head erect, and the bearing of a soldier. He said: 'I who delight in the company of kings pay no regard to other creatures. I cover my eyes with a hood so that I may put my feet on the king's hand. I am perfectly trained in polite behaviour and practice abstinence like any penitent so that when I am taken before a king I can perform my duties exactly as is expected of me. Why should I see the Simurgh, even in a dream? Why should I rush heedlessly to him? I do not feel called upon to take part in this journey. I am content with a morsel from the king's hand; his court is good enough for me. He who plays for royal favours obtains his desire; and to be agreeable to the king I have only to take flight through the boundless valleys. I have no other wish than to pass my life joyfully in this fashion—either waiting for the king or hunting at his pleasure.'

from *The Conference of the Birds,*
FARID UD-DIN ATTAR, 12th century

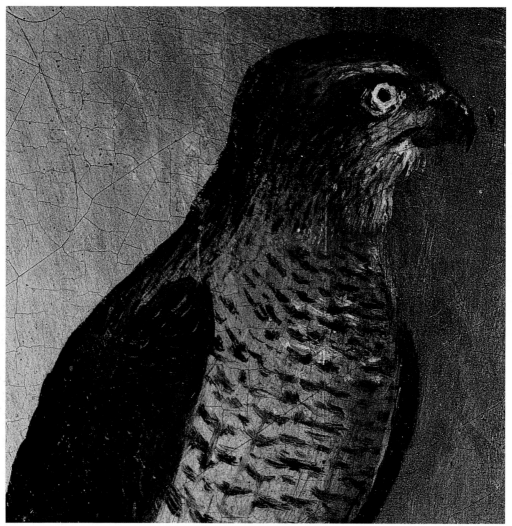

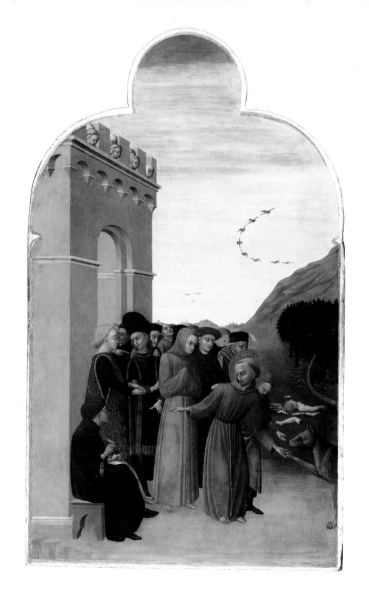

Sassetta (1392?–1450) Italian
*The Legend of the Wolf of Gubbio*
1437–44

Of the most holy miracle that St Francis wrought when he
converted the fierce wolf of Agobio...

Making the Sign of the Cross he went forth from that place with
his companions, putting all his trust in God. And the others
misdoubting to go further, Saint Francis took the road to the place
where the wolf lay...

And done the preaching, Saint Francis said: Give ear, my
brothers. Brother Wolf, who standeth here before me, hath
promised me and plighted his troth to make his peace with you,
and to offend no more in anything: and do ye promise him to give
him every day whate'er he needs: and I am made his surety unto
you that he will keep this pact of peace right steadfastly. Then
promised all the folk with one accord to give him food abidingly.
Then quoth Saint Francis to the wolf before them all: 'And thou,
Brother Wolf, dost thou make promise to keep firm this pact of
peace, that thou offendest not man nor beast, nor any creature?'
And the wolf knelt down and bowed his head: and with gentle
movements of his body, tail and eyes, gave sign as best he could
that he would keep this pact entire...And thereafter this same wolf

lived two years in Agobio; and went like a tame beast in and out the houses, from door to door, without doing hurt to any, or any doing hurt to him, and was courteously nourished by the people; and as he passed thuswise through the country and the houses, never did any dog bark behind him.

At length, after a two years' space Brother Wolf died of old age; whereat the townsfolk surely grieved, sith marking him pass so gently through the city, they minded them the better of virtue and sanctity of Saint Francis.

from *Little Flowers of St Francis*, 13th century

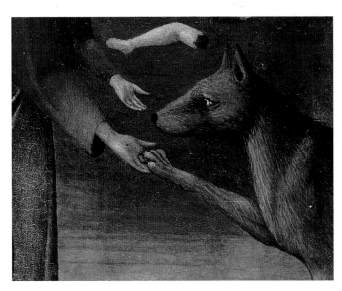

WILLEM MARIS (1844–1910) Dutch
*Ducks alighting on a Pool*
about 1885

Whither, midst falling dew,
While glow the heavens with the last steps of day
Far, through their rosy depths, dost thou pursue
　　Thy solitary way?

Vainly the fowler's eye
Might mark thy distant flight to do thee wrong,
As, darkly painted on the crimson sky,
　　Thy figure floats along...

All day thy wings have fanned
At that far height the cold thin atmosphere;
Yet stoop not, weary, to the welcome land,
　　Though the dark night is near.

And soon that toil shall end,
Soon shalt thou find a summer home and rest,
And scream among thy fellows; reeds shall bend
　　Soon o'er thy sheltered nest.

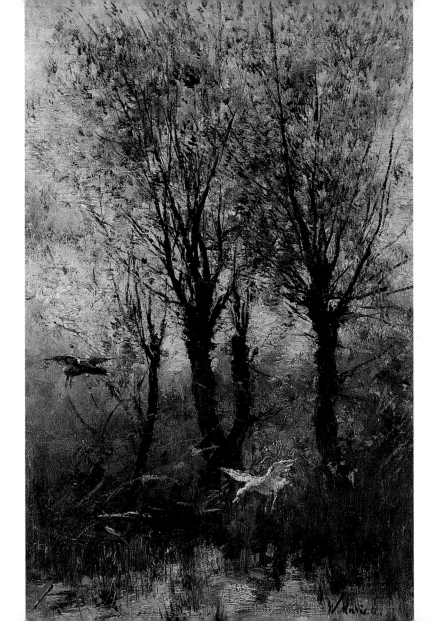

Thou'rt gone, the abyss of heaven
Hath swallowed up thy form; yet on my heart
Deeply hath sunk the lesson thou hast given,
   And shall not soon depart.

He who, from zone to zone,
Guides through the boundless sky thy certain flight,
In the long way that I must tread alone
   Will lead my steps aright.

*Rambles in Winter,*
WALT WHITMAN, 19th century

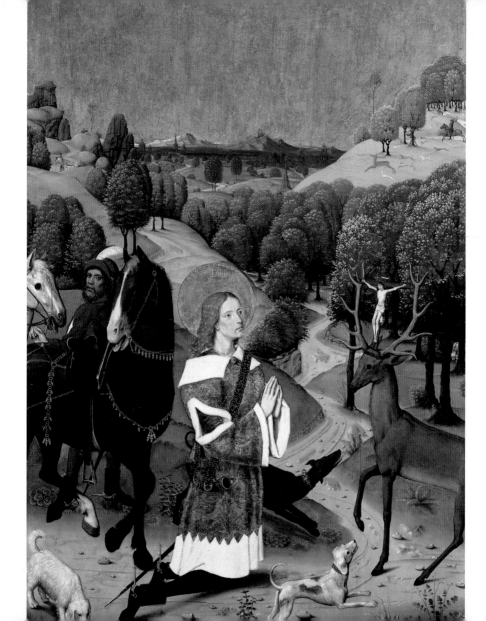

WORKSHOP OF THE MASTER OF THE LIFE
OF THE VIRGIN (active second half of the
15th century)
*The Conversion of Saint Hubert*
probably about 1480–5

...And through yon gateway, where is found,
Beneath the arch with ivy bound,
Free entrance to the church-yard ground:
And right across the verdant sod
Towards the very house of God;—
Comes gliding in with lovely gleam,
Comes gliding in serene and slow,
Soft and silent as a dream,
A solitary doe!
White she is as lily of June,
And beauteous as the silver moon
When out of sight the clouds are driven,
And she is left alone in heaven;
Or like a ship some gentle day
In sunshine sailing far away,
Or glittering ship, that hath the plain
Of ocean for her own domain.

from *The White Doe of Rylstone,*
WILLIAM WORDSWORTH, 1807

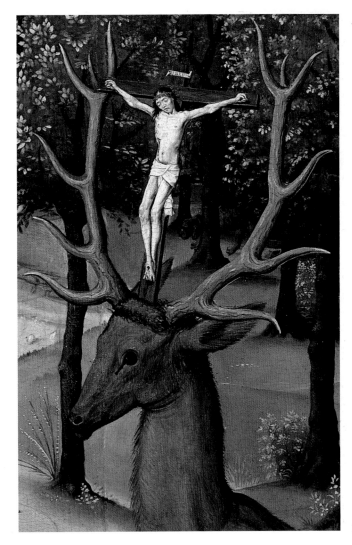

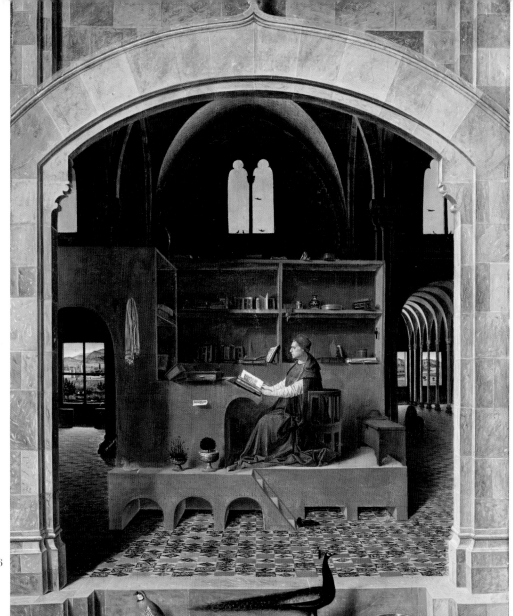

ANTONELLO DA MESSINA (active 1456; died 1479) Italian
*Saint Jerome in his Study*
about 1475

Next came the golden Peacock, with feathers of a hundred—
what shall I say?—a hundred thousand colours! He displayed
himself, turning this way and that, like a bride. 'The
painter of the world,' he said, 'to fashion me took in his
hand the brush of the Jinn. But although I am Gabriel
among birds my lot is not to be envied. I was friendly with
the serpent in the earthly paradise, and for this was ignominiously
driven out. They deprived me of a position of trust,
they, who trusted me, and my feet were my prison. But I
am always hoping that some benevolent guide will lead me
out of this dark abode and take me to the everlasting mansions.
I do not expect to reach the king you speak of, it will
suffice me to reach his gate. How can you expect me to
strive to reach the Simurgh since I have lived in the earthly
paradise? I have no wish except to dwell there again.
Nothing else has any meaning for me.'

 The Hoopoe replied: 'You are straying from the true Way.
The palace of this King is far better than your paradise.
You cannot do better than to strive to reach it. It is
the habitation of the soul, it is eternity, it is the object of our
real desires, the dwelling of the heart, the seat of truth.
The Most High is a vast ocean; the paradise of earthly bliss
is only a little drop; all that is not this ocean is distraction.

When you can have the ocean why will you seek a drop of evening dew? Shall he who shares the secrets of the sun idle with a speck of dust? Is he who has all, concerned with the part? Is the soul concerned with members of the body? If you would be perfect seek the whole, choose the whole, be whole.'

<div style="text-align: right;">from <em>The Conference of the Birds,</em><br>
FARID UD-DIN ATTAR, 12th century</div>

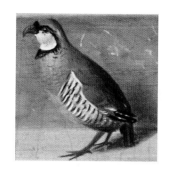

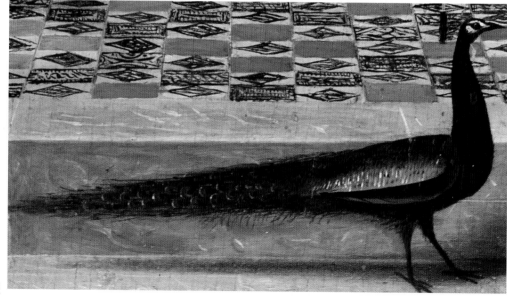

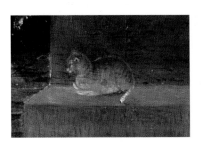

# Artists & Paintings

MASTER OF THE CASTELLO
NATIVITY
*The Nativity*
tempera on wood,
21.5 x 65.5 cm, p.114

MAUVE, Anton
*Milking Time*
oil on canvas,
29.8 x 50.2 cm, p.2

MESSINA, Antonello da
*Saint Jerome in his Study*
oil (identified) on lime,
45.7 x 36.2 cm, p.136

MURILLO, Bartolomé
Esteban
*The Infant Saint John with
the Lamb*
oil on canvas,
165 x 106 cm, p.96

OS, Jan van
*Fruit, Flowers and a Fish*
oil on mahogany,
72.2 x 56.7 cm, p.104

PERRONNEAU, Jean-Baptiste
*A Girl with a Kitten*
pastel on paper,
59.1 x 49.8 cm, p.53

PISANELLO
*The Vision of Saint Eustace*
tempera on wood,
54.5 x 65.5 cm, p.118

ROUSSEAU, Henri
*Tiger in a Tropical Storm
(Surprised!)*
oil on canvas,
129.8 x 161.9 cm, p.14

RUBENS, Peter Paul
*A Roman Triumph*
oil on canvas stuck down on
oak panels
86.8 x 163.9 cm, p.8

SASSETTA
*The Legend of the Wolf of
Gubbio*
tempera on poplar,
86.5 x 52 cm, p.124

SAVERY, Roelandt
*Orpheus*
oil on oak,
53 x 81.5 cm, p.22

SPRUYT, Johannes
*Geese and Ducks*
oil on canvas,
119.5 x 155.5 cm, p.110

STUBBS, George
*A Gentleman driving a Lady
in a Phaeton*
oil (identified) on oak,
82.5 x 101.6 cm, p.82

*Whistlejacket*
oil on canvas,
292 x 246.4 cm, p.62

UCCELLO, Paolo
*The Battle of San Romano*
tempera on poplar,
182 x 320 cm, p.66

*Saint George and the Dragon*
oil on canvas,
56.5 x 74 cm, p.26

VELDE, Adriaen van de
*A Goat and a Kid*
oil on canvas,
42.5 x 50.5 cm, p.90

WORKSHOP OF THE MASTER
OF 1518
*The Flight into Egypt*
oil on oak,
80 x 69.5 cm, p.106

WORKSHOP OF THE MASTER
OF THE LIFE OF THE VIRGIN
*The Conversion of Saint
Hubert*
oil (identified) on oak,
123 x 83.2 cm, p.132

WRIGHT OF DERBY, Joseph
*Mr and Mrs Thomas Coltman*
oil on canvas,
127 x 101.6 cm, p.74

# Writers & Works

# Acknowledgments

Turner, W.J
(1884–1946), British
*India,* 1916, p.15

Whitman, Walt
(1819–1892), American
*Song of Myself,* 1855, p.30

*Rambles in Winter,*
19th century, p.128

Wordsworth, William
(1770–1850), English
*The White Doe of Rylstone,*
1807, p.133

Yeats, William Butler
(1865–1939), Irish
*He Bids His Beloved Be At
Peace,* 1899, p.86

Zabolotsky, Nikolay
Alekseevich
(1903–1958), Russian
*The Face of a Horse,* 1926,
p.63. Translated by Daniel
Weissebort, 1999

Zola, Emile
(1840–1902), French
*The Cat's Paradise,*
19th century, p.36

The editor and publishers gratefully
acknowledge permission to reprint
copyright material below. Every effort
has been made to contact the original
copyright holders of the material
included. Any omissions will be
rectified in future editions.

Excerpt from *The Diary of a Church
Mouse* by John Betjeman by
permission of John Murray
(Publishers) Ltd.

*Come into Animal Presence* by Denise
Levertov, from *Selected Poems of
Denise Levertov,* published by
Bloodaxe Books. Copyright © 1966
by Denise Levertov. Reprinted by
permission of New Directions
Publishing Corp.

Excerpt from translation of *Devils* by
Alexander Sergeyvich Pushkin by
Genia Gurarie. © Genia Gurarie
1995.

Translation of *The Face of the Horse*
by Nikolay Alekseevich Zabolotsky by
Daniel Weissebort from *Nikolay
Zabalotsky: Selected Poems,* published
by Carcanet Press Ltd.
*Francis Jammes: A Prayer to Go to
Paradise with the Donkeys* from
*Things of This World,* copyright ©

1955 and renewed 1983 by Richard
Wilbur, reprinted by permission of
Harcourt, Inc in the USA and Faber
and Faber Ltd in the UK.

*India* by W.J. Turner by permission
of Methuen Publishing Ltd.

Excerpt from *Me & My Bike* by Dylan
Thomas copyright © The Estate of
Dylan Thomas. Reproduced by
permission of David Higham
Associates.

*He Bids His Beloved Be At Peace* by
William Butler Yeats by permission
of A.P. Watt and Michael B. Yeats in
the UK. Reprinted in the USA by
permission of Scribner, a Division of
Simon & Schuster from THE
COLLECTED POEMS OF W.B.
YEATS, Revised Second Edition
edited by Richard J. Finneran.
Copyright © 1983, 1989 by Anne
Yeats.

Excerpt from *St Martha and the
Dragon* by Charles Causley from
*Charles Causley: Collected Poems
1951–2000* published by Macmillan.
Reproduced by permission of David
Higham Associates.

Melchior d'Hondecoeter, detail of *A Cock, Hens and Chicks*, 1668–70

Title page: Anton
   Mauve, *Milking Time*,
   about 1871
Exotic title page: Peter
   Paul Rubens, *A Roman
   Triumph*, about 1630
Cherished title page:
   Dutch(?), *Sportsmen
   Resting*, about 1650
Noble title page: Rosa
   Bonheur and Nathalie
   Micas, *The Horse Fair*,
   1855
Humble title page:
   Adriaen van de Velde, *A
   Goat and a Kid*, 1655–72
Wild title page: Pisanello,
   *The Vision of Saint
   Eustace*, mid-15th century